JUNE CRAWSHAW

Watercolour
Made Easy

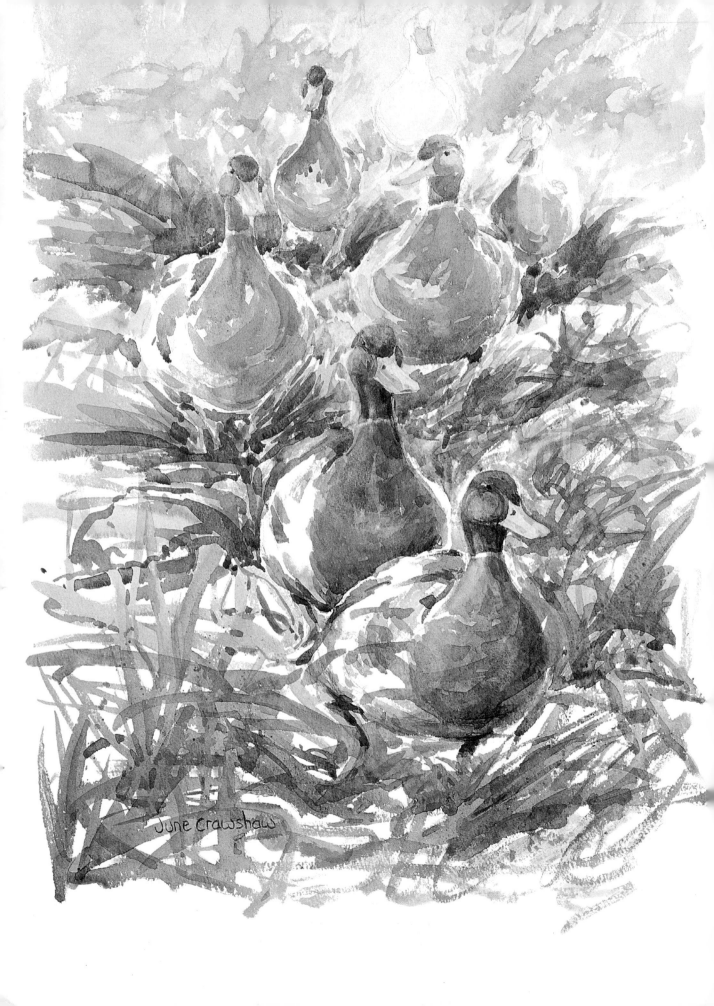
June Crawshaw

JUNE CRAWSHAW

Watercolour Made Easy

PRACTICAL PROJECTS TO INCREASE YOUR CONFIDENCE

HarperCollins*Publishers*

ACKNOWLEDGEMENTS

I dedicate this book to my wonderful mother.
I would also like to thank the following people, without
whose help I would never have written this book:
Cathy Gosling of HarperCollins for having confidence in me;
Flicka Lister for her sympathetic editing and Mary Poole
for typing the manuscript. Finally, my grateful thanks to
Alwyn, my husband, whose constant encouragement has inspired
and kept me progressing with my painting.

First published in hardback in 1995 by
HarperCollins*Publishers*
77-85 Fulham Palace Road
Hammersmith
London W6 8JB

The HarperCollins website address is
www.**fire**and**water**.com

Collins is a registered trademark of
HarperCollins Publishers Limited

This edition first published
in paperback in 1999

00 02 03 01
4 6 8 9 7 5 3

**A catalogue record for this book is
available from the British Library**

ISBN 0 00 413390 0

*Editor: Flicka Lister
Design Manager: Caroline Hill
Designer: Joan Curtis
Photographer: Nigel Cheffers-Heard*

Colour origination by Colourscan, Singapore
Printed and bound by Printing Express Ltd., Hong Kong

◆ Contents ◆

◆ *Introduction* ◆

*A*lthough I am now a professional painter, I never attended art school – in fact, I didn't start painting seriously until I was in my early forties. However, I do remember exactly how a beginner to painting feels! As you read through this book, my aim is to make watercolour painting easier and more enjoyable for you, while building up your confidence and inspiring you to take up your brush and work through the painting exercises. I also hope to remove many of your fears and inhibitions by sharing my own painting experiences with you – I am sure I had the same frustrations and worries that some of you will have!

EARLY BRUSHSTROKES

As a child I was always drawing and I enjoyed anything to do with painting and sketching until I left school. I didn't do any more painting until I was in my late twenties when my husband Alwyn, who is also an artist, and I decided to open a gallery. It was great fun and very much a family affair, since Alwyn, his sisters and cousin all exhibited their work. This inspired me to start painting again. After many hours of practising, some of my paintings (mainly of dogs and other animals worked in a very simple way) were hung in the gallery and, to my great surprise and joy, quite a few of them sold! Sadly, my motivation to paint suffered a setback when the gallery had to close because the building was due for demolition.

I had always dabbled in crafts such as needlework, patchwork, embroidery, enamelling and collage, and eventually decided to try my hand at something new. I started pottery when my youngest child went to school and soon this became my main interest – after my family, of course! Although I still had a burning desire to paint, I just hadn't got the confidence to begin again. By the time we moved to Devon in 1980, I was potting on a professional basis. I was now in my forties, my two daughters were grown-up, and my son was ten years old.

June Crawshaw in her studio.

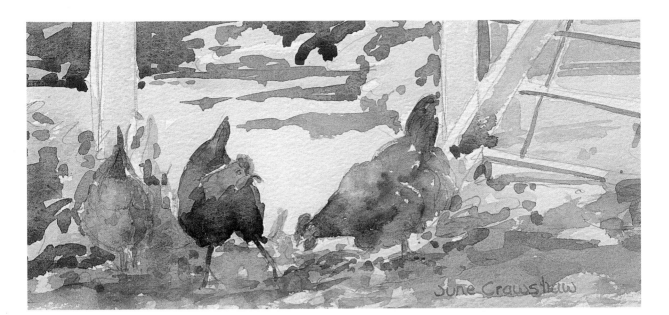

Painting Courses in Devon

When Alwyn started running painting courses at a nearby country hotel, he suggested I went along as one of his students. I had very mixed feelings; I desperately wanted to paint but now had even less confidence, since I hadn't picked up a brush for years! With trepidation, I said yes.

The courses were wonderful but I always had a bad attack of nerves before going on them and it wasn't very long before I found that many of the students felt exactly the same as I did. It is strange how you always think you will be the only beginner and that everyone else is going to be better than you. Once you discover that there are people above, below and on the same level as you, you can begin to relax and enjoy yourself.

The most important lesson for a beginner is not to think you have to paint a complete picture straightaway. First practise lots of colour mixing and learn how to put paint on paper with a brush – just play around with the paint and enjoy it. Start by painting something uncomplicated like my apples on the next page. It is very important to practise painting this sort of simple subject.

Half-Hour Exercises

Apart from making our nerves jangle somewhat, the half-hour exercises on our courses were fun and taught us a great deal. We had to draw and

▲ *Chickens*
Cartridge paper
15 × 29 cm (6 × 11½ in)
A recent painting of one of my favourite subjects. Chickens can be great fun to paint. This one worked out well and is a nice free and happy watercolour.

▼ *Dog*
Acrylic on coloured paper
28 × 19 cm (11 × 7½ in)
I did a few practice runs before I painted this picture.

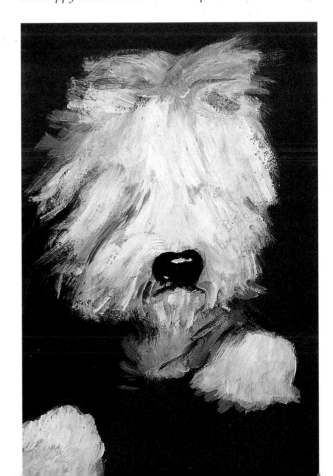

paint everything in just thirty minutes, with Alwyn on the stopwatch telling us how much time we had left to paint. It made us look carefully at the subject, simplifying it and painting it freely. There was no time for fiddling!

Some people would paint a single object, while other more experienced students would paint whole groups of things, but we were all usually pleasantly surprised by our results and quickly gained confidence. It didn't matter if the colours ran or if they weren't exactly right, we just had to keep within the time limit. We all agreed that it really helped us to to lose our fear of that blank piece of paper. You couldn't sit looking at it wondering what to do – there wasn't time for that. To build your confidence, I recommend you do some half-hour exercises yourself – but try not to cheat on time!

FINDING TIME TO PAINT

My painting developed slowly at first, mainly because I didn't practise enough! Then I had my most important breakthrough – I decided to think of painting as 'work', in the same way as ironing,

or other household chores. That way I could spend a whole morning or a whole afternoon practising without feeling guilty. Naturally, this wasn't always as simple as it sounds, and my willpower wasn't always that strong – on a lovely summer's day, seeing the garden needed attention, it was very hard to paint rather than weed! I had further distractions when our grandchildren were born. If my daughter called in with them, that was the end of work! It was really after my last born had flown the nest, and my paintings were selling, that I had a real routine of 'work' painting. But I still made enough time to practise and paint before then.

STILL-LIFE

Painting still-life subjects is a great way of learning and there are always plenty of subjects around the house for you to paint. This will also build your confidence and help you to discover about shape and form. 'Still-life' can be anything from a single piece of fruit to a full breakfast setting, and you can paint objects as you find them, or arrange them to please yourself.

Apples
Watercolour paper 72 lb
30 × 26 cm (12 × 10½ in)
I can't remember exactly how I painted these apples or if I painted them or the background first. But I do remember looking for the highlights and leaving white unpainted paper for the lightest ones. Notice how I forgot and painted over these on the apple on the left! This is what practice is all about. I let the red paint run into the table making the reflections on the polished surface, although I don't think it looks so convincing now! The result wasn't a masterpiece – it was painted a long time ago when I was learning – but I was very pleased with it at the time.

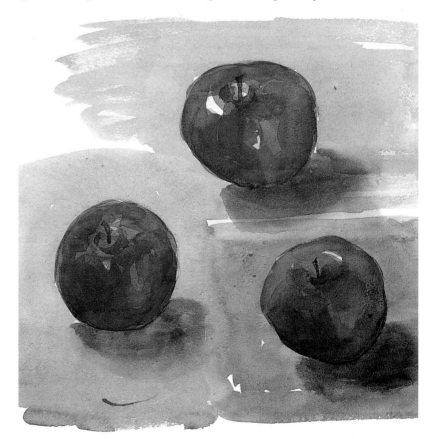

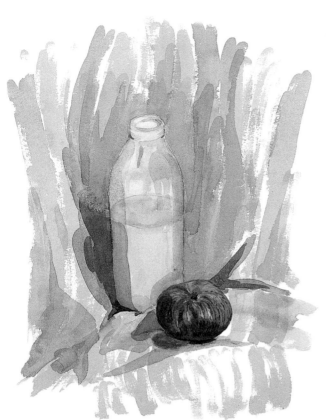

Milk bottle
Bockingford 140 lb
140lb, 38 × 29 cm (15 × 11½ in)
*One of my early still-life practice
paintings. The milk bottle is not
very good at the top – I always
found ellipses very difficult. The
apple and the shadows are rather
dark. The apple, because of the
dark shadows behind, looks as if it
has a black tail stuck to it! I was
trying to make glass look like
glass, and a milk bottle was a very
difficult subject for me. But at the
time I was pleased with the result.*

However uninteresting some objects may seem, when you shine a light on them, or the sunlight from the window is behind them, they can suddenly become very exciting and inspiring. While I was learning, I did many still-life paintings – the milk bottle, above, is one of my early still-life practice paintings.

By painting subjects like this, you learn so much. For example, the illusion of glass, whether it is a window or a bottle, is created by the reflections you can see in it, or whatever you can see through it. Shadows are the same whether they are on the side of a house, under a tree, or on an apple. If you half close your eyes, or squint through them, you will see how dark a shadow is, or how light a highlight can be, whether it is on a milk bottle or a house. So practising still-life prepares you for whatever you paint, whether it is indoors or out, and will give you confidence.

DATING WORK

When you are learning, it is a good idea to date your work, preferably on the back, and do keep all your old paintings. I would have thrown a lot

of mine away if Alwyn hadn't insisted I kept them. Of course, I am glad now because I can look back and see how much my painting has developed over the years. Mind you, there are times when I think: 'that painting looks good – I wonder if I could do it again'! However, if the painting is a few years old, you can usually see a definite improvement – even if, at the time, you thought you had finally made it! This really gives you confidence and the incentive to keep going.

I practised on my own, apart from the courses, and, as I improved, I sold some of my paintings. This was a fantastic boost to my confidence. The first painting I sold was at our local art society exhibition and I don't think I will ever get such a thrill selling a painting as I did then. It wasn't the money – it was the excitement of knowing that somebody liked my painting enough to buy it and hang it on a wall in their home.

VENTURING OUTSIDE

If you haven't painted outside very often it can be extremely daunting to paint in public. The first summer that we moved to Devon, the

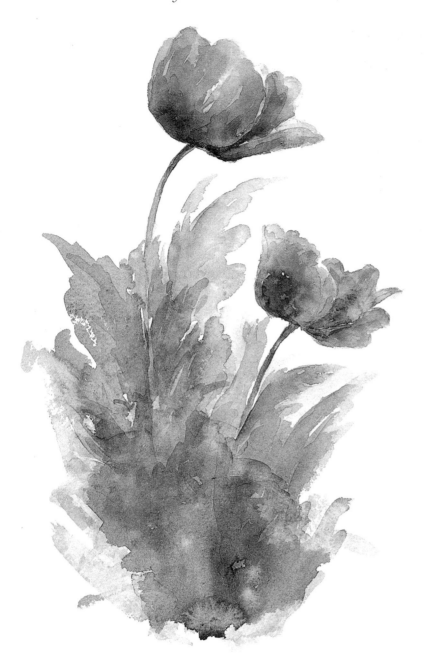

Poppies
Watercolour paper
33 × 20 cm (13 × 8 in)
I was proud of this watercolour painting at the time. It is quite simple, but even now I still rather like the flowers. I painted it outside from life, on a good quality watercolour paper as a special treat. The leaves got rather confused but at the time I wasn't experienced enough to cope with all that 'greenery'.

garden – which was already a fairly well-established one – was covered in giant poppies with bluey-green, spiky leaves and flowers as big as my hand in vivid reds, mauves and pinks. They were everywhere and some were as tall as me. I had great fun (and frustration!) trying to paint them and my painting, above, shows one of my early efforts. If you haven't a garden, try painting the view from your window. It is good preparation for painting outside and it will give you confidence for when you do the real thing.

When you first go further afield to paint, set yourself a simple task and start with a tree, a single flower, a gate or anything else that takes your fancy. Don't feel you have to paint everything in front of you.

PAINTING WITH OTHER PEOPLE

You may find it easier to paint with other people by joining an art class or society, or simply teaming up with a friend. In 1987, my friend Primrose started to come once a week to paint with me. She was keen to learn and by then I had quite a lot of painting and teaching experience

through my involvement in Alwyn's courses. We had lots of laughs and I hope she learnt a little, too. We painted in the garden in good weather and indoors the rest of the time.

Alwyn continued to run his painting courses for about nine years until we moved away from the district. In that time I progressed from being a novice to a painter and teacher. The students would tell me their painting worries, especially the ones who were too nervous to tell Alwyn! If I couldn't help, I would tell him and he would solve their problems. We made a good partnership, and our students enjoyed the way we ran these courses.

ON THE MOVE

By the time we moved to Dawlish in 1989, I was painting in earnest. This was a very eventful year for both of us. We had a major exhibition in

Ducks
Oatmeal tinted Bockingford
28 × 30 cm (11 × 15 in)
Ducks are a favourite subject of mine. Working on tinted paper gives your watercolour painting a sunny or evening look.

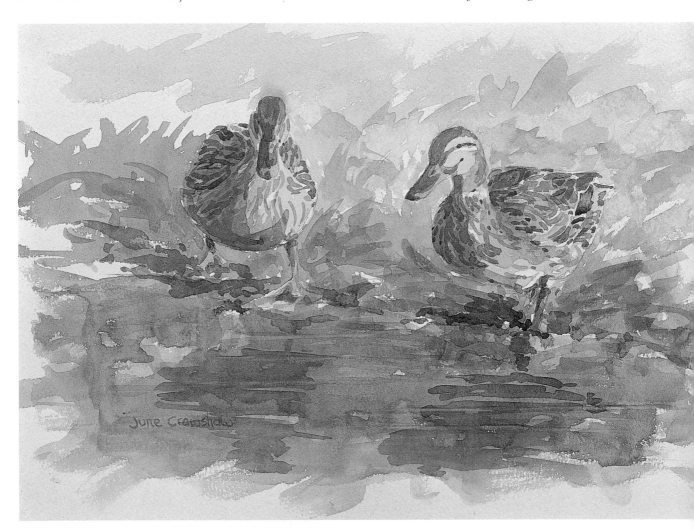

11

Bristol; opened our own gallery and I helped Alwyn with his first TV series. We also took our first painting course abroad.

I still somehow found the time to go out and paint, I'm glad to say. One of my loveliest memories of moving to Dawlish was sketching and painting the ducks that live on the small river that runs through the town, see page 11. During the hot summer months, Primrose and I painted the holiday-makers on our local beach, see below. This gave me the confidence to sit among all those people and paint without worrying. Perhaps I may never have done that on my own, so thank you, Primrose!

Actually, although I enjoy doing beach paintings, I still find that if I haven't painted on the beach for some time, I am very nervous of being watched. But remember the more you do, the more confident you become. You can always hide behind a deck chair or a large rock!

Dawlish beach
Cartridge paper
22 × 29 cm (8½ × 11½ in)
I painted this beach scene the first summer we moved to Dawlish. Looking back, I think I was very brave to tackle all those deck chairs but it turned out quite well!

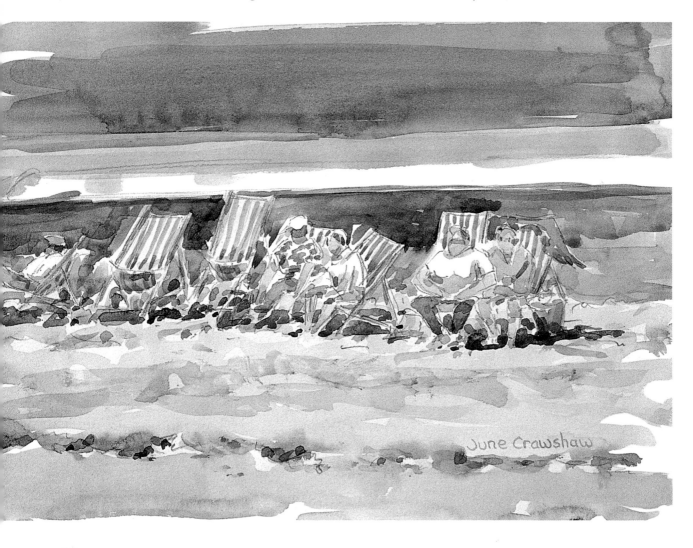

June Crawshaw

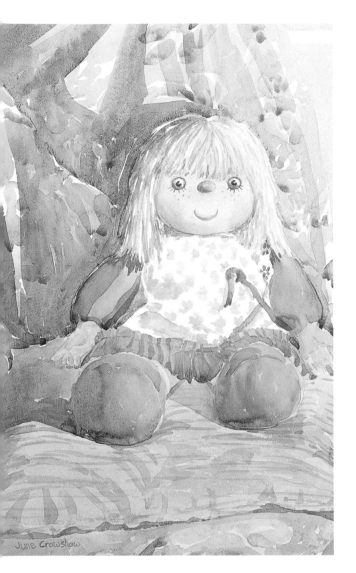

Doll
Bockingford 200 lb
56 × 38 cm (22 × 15 in)
*The doll that started me painting
dolls. Placed on this patchwork
cushion, she makes a very
colourful subject.*

STEPS TO SUCCESS

I can't quite believe how much I have achieved in the last ten years. I have become a professional painter. In 1987, I was thrilled to be made a member of the Society of Women Artists. I was made a member of the British Watercolour Society in 1988 and this gave me great pleasure.

Around that period I had been given a fun present from Alwyn – a big doll with pink wool hair and a big smile. I decided it would be lovely to paint her in my studio sitting on my oil painting easel. This painting was a big success and started my doll painting period. I submitted some of my doll paintings to the Society of Women Artists when I was made a member. I also have had two fine art prints of dolls published. In fact, I still have to pinch myself to believe that I have done these things. Of course, I couldn't have achieved most of them without the help and support of my family – plus, of course, lots of hard work and practice. Naturally, I have had my share of ups and downs which have included times of great joy as well as despair!

One of my most nerve-wracking experiences was appearing with Alwyn in his TV series *Crawshaw Paints On Holiday*. I had helped in the making of Alwyn's *Learn to Paint* videos and his previous TV series but had never appeared in front of the cameras. Now I was persuaded by our producer David and director Ingrid to paint and explain to the viewers what I was doing as I was working. I still can't believe I did it – especially when I think back to my early painting days when I hadn't even got the confidence to put paint on to that blank piece of paper!

Dawlish is a typical English West Country seaside town and an ideal place to paint in the summer when it is crowded with families on holiday. I have become a great 'people watcher' and I love to paint groups of people enjoying themselves, see my picture below. However, I am very lucky because, from my studio, I can see the sea and over the town to the distant hills. With the hustle and bustle of the beach gone, and I can work in my own quiet environment.

PAINTING ABROAD

Alwyn and I now take courses abroad each year and we have visited some beautiful places – Greece, Provence, Tuscany and Majorca to name just a few. The scenery has taken my breath away at times. But I do find that until you adjust to the environment, it is difficult to paint as you would in a familiar landscape. Ideally, you need a few days to really absorb everything. If you haven't

Beach scene
Bockingford 200 lb
56 × 39 cm (22 × 15 in)
I painted this beach scene in my studio, using pencil sketches and photographs as models. I have composed my own picture by taking the figures from different sketches and photographs and putting them where I want them. You need to have quite a lot of painting experience to do this. Do plenty of sketching and painting from life, outside on the beach if possible. If not, get plenty of indoor practice, from photographs and sketches.

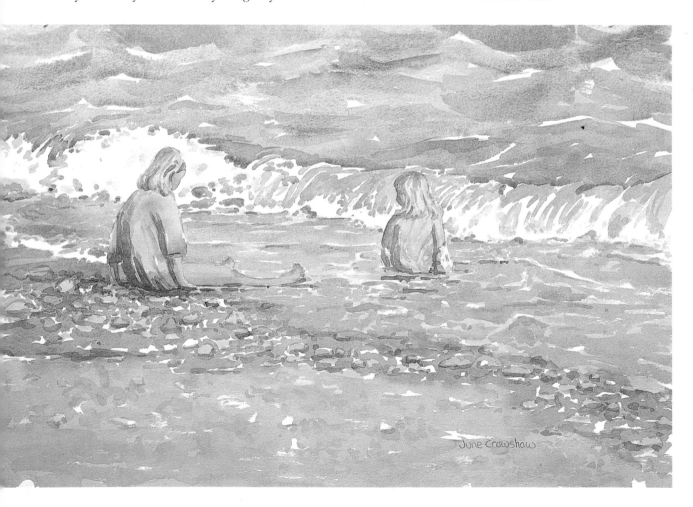

June Crawshaw

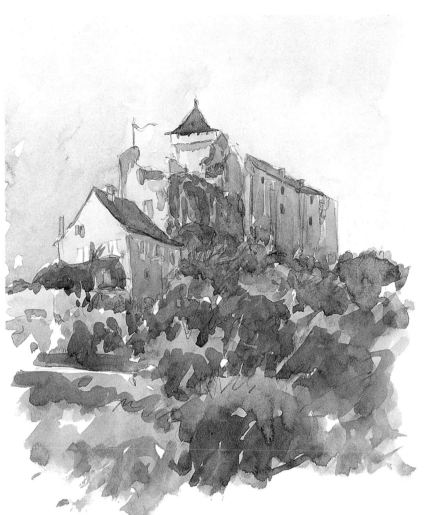

Chateau de Castelnaud
Cartridge paper
29 × 22 cm (11½ × 8½ in)
I managed to squeeze this one in during our painting course in the Dordogne in France. The weather was so wet! We were all painting from a café that had one of those outside eating areas with a glass roof and open sides. This castle was one of the views and looked very dramatic with the dark sky and the light hitting the side of the building – when you could see it through the rain! You often have to exaggerate the lights and darks to make an interesting painting, as I did here. This was painted in my sketchbook.

much time, try to get to work straightaway and, through painting as much as possible, you will come to understand the new scenery very quickly. We have had some memorable times painting and teaching abroad and thoroughly enjoyed ourselves. Of course, when you are teaching, you don't have so much time for your own painting. But I always manage to squeeze a few in – the painting above is one of them!

WORRY LESS – PRACTISE MORE!

This book is my chance to help other people who want to paint to get over the hurdles of 'learning' and to enjoy their painting. If I could start my painting life again, I would begin earlier. Most importantly, I would practise more and worry less. Worrying takes a lot of the enjoyment out of learning to paint and, like most people, I worried

a great deal to begin with. I also wanted to run before I could walk but now realise that it wasn't a race and that I would have got there much faster if I'd practised and gone at my own pace. After all, you can't play the piano without many hours of practising the scales!

Everyone has different goals. Some people want to paint only for their own enjoyment, which is great; others want to develop their painting as far as it can go. You can spend the rest of your life progressing and practising – I still enjoy doing this, as I am sure you will.

Don't forget that, if you paint a simple object to begin with, you will achieve success. If you try to paint a full picture at first, the chances are it will be a failure and you will feel that you an't paint – and that's the wrong way to start. With success imprinted on your brain, you are halfway there. The rest is practice, so enjoy yourself and don't worry.

ABOUT THIS BOOK

To help you build up your confidence as you learn to paint watercolour, this book is divided into four main subject themes. These are:

Flowers
Ducks and Chickens
Simple Landscapes
Beach Scenes

They are all subjects I love to paint and I hope you will enjoy them, too. Each subject section has a set of exercises and I suggest that you work through the sections, taking your time with each exercise and practising it as many times as you wish before you go on to the next one. For example, it is better to go through the whole of the flower exercises before you move on to the ones for ducks and chickens.

COLOUR MIXING

The first exercise in each section is colour mixing and, to make life simpler for you, I show you the colours I have mixed and how they have been used to paint the subject.

PENCIL SKETCHING

The second exercise is pencil sketching. I show you how to sketch simple shapes and get more form and depth into your drawing by pencil shading. This in turn will develop your powers of observation.

PAINTING WITHOUT DRAWING

In this exercise, you will put away your pencils and paint colours freely onto the paper to form the shape of your subject. This is where you can get really artistic and it's a very exciting way of getting used to the medium of watercolour.

WATERCOLOUR SKETCHING

In the fourth exercise, I show how to take your sketchbook and paints outside to do simple watercolour sketches. These little paintings will give you confidence for your next painting step.

DEMONSTRATIONS

In the demonstration exercise in each section, I show you how to paint a picture from start to finish in easy-to-follow stages. In this way, you can see exactly how it was done and which colours I used.

WORKING FROM A PHOTOGRAPH

I also include a demonstration painting showing you how to paint from a photograph instead of the real subject. We can't always go outdoors to paint and a photograph can be a good source of information and inspiration.

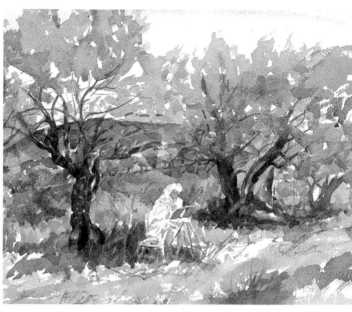

◆ Flowers ◆
Your garden or florist can be useful sources of inspiration through the seasons.

◆ Simple Landscapes ◆
With practice you will soon have the confidence to paint outside.

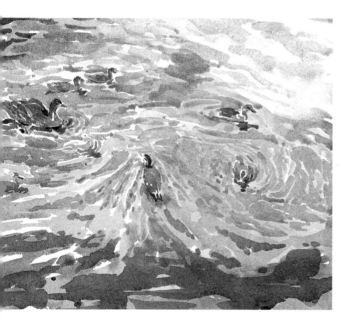

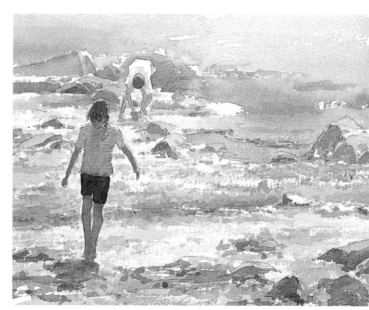

◆ Ducks & Chickens ◆
Painting and sketching from life will help to develop your artistic skills.

◆ Beach Scenes ◆
A beach holiday often provides a perfect opportunity to observe people.

I am sure that by reading this book and working carefully through the exercises you will find painting not only more enjoyable but easier, too. Good luck!

◆ *Materials* ◆

*F*irst time painters are often confused and intimidated by the choice of products offered by art shops and buy far too much. One of the beauties of watercolour painting is that you don't need a lot of expensive equipment to get started and I have deliberately kept to fairly basic materials in this book. In addition to paints and brushes, you'll need a 2B pencil for sketching or drawing in pictures before painting, a penknife to sharpen it and a putty eraser. Don't be afraid to use the eraser – it's part of an artist's kit.

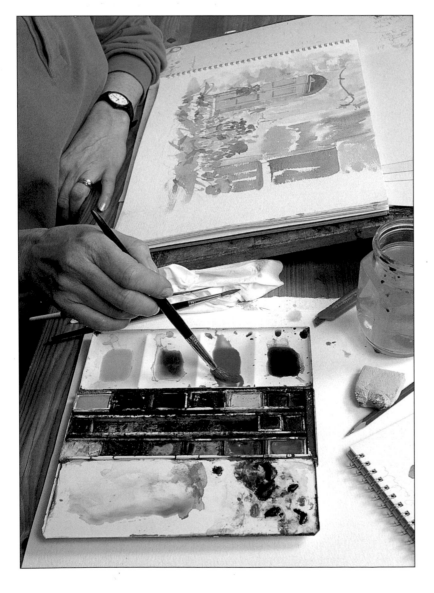

Indoors or out, you don't need much equipment to paint successfully in watercolour. You can start very simply with plenty of paper to practise on, the three primary colours of red, yellow and blue, a watercolour brush, something to mix the paint on and, finally, a pot to hold the water. With this basic kit, you are ready to go!

PAPER

A spiral-bound sketchbook of cartridge paper is next on the list. My favourite size is A4 (30 cm x 21 cm / 12 x 8¼ in) and I always use this when sketching or painting outside.

When working inside or outside, I use white or tinted Bockingford watercolour paper which comes in different sizes and thicknesses as single sheets or in spiral-bound pads. I use Waterford and occasionally Whatman watercolour papers which have a choice of three surfaces: Rough, with a rough textured surface; Hot Press, with a smooth surface, and Not, the most popular surface which is in-between the two. As you become more experienced, you can have great fun experimenting with different types of paper.

COLOURS

Although my paintbox has room for lots of pans and half pans of paint, I normally use just seven colours: two yellows (Cadmium Yellow Pale and Yellow Ochre); two blues (French Ultramarine and Coeruleum Blue); two reds (Crimson Alizarin and Cadmium Red) and one ready-mixed green (Hooker's Green No. 1). I use Daler-Rowney Artists' quality Watercolour paints but Georgian Watercolours (a grade lower) are a good, less expensive alternative.

I suggest you use my colours to work through the exercises in this book. You can add to them later if you wish but to begin with you'll find it easier if you start with these. Using just a few colours will also teach you how to mix colours to obtain different shades.

BRUSHES

An artist's brushes are very important. My basic watercolour painting kit contains just three. These are two Rowney Kolinsky round sable brushes (a Series 40 No. 10 and a Series 43 No. 6) plus a synthetic Dalon Series D99 No. 2 'Rigger' which I use for detail work.

When applying washes in watercolour you need a brush that can hold plenty of watery paint. I personally find a real sable unbeatable for this but price and preference will come into your choice of brushes. Many artists are very happy with synthetic brushes and Dalon brushes are excellent.

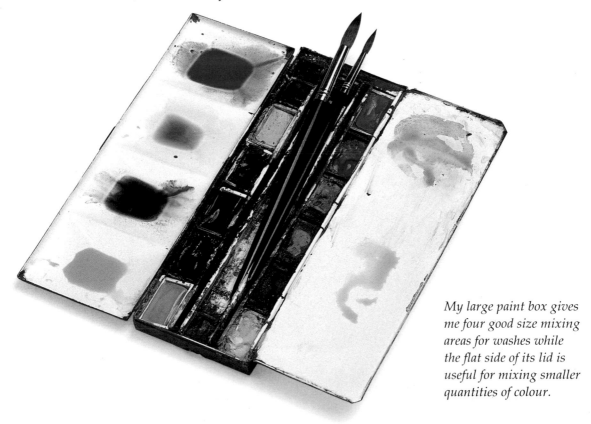

My large paint box gives me four good size mixing areas for washes while the flat side of its lid is useful for mixing smaller quantities of colour.

◆ *Simple Techniques* ◆

A very important first step in watercolour painting is learning how to paint a wash. Washes are so much a part of this lovely medium and the amount of water you use is often just as important as the amount of paint. When painting any wash, your paper should be at a shallow angle to allow the paint to run down and mix together. Don't move the paper until it is dry or the paint will run in a different direction and spoil your wash.

Practise the flat wash below and, once you feel happy with your efforts, try the graded wash on the opposite page. I have used several colours for my graded wash and you can see how they merge together because they are wet. This technique can give some very exciting effects. Finally, try out some filling-in strokes and practise painting shadows.

Flat wash

FLAT WASH

Mix plenty of watery French Ultramarine in your palette. Then load your brush and paint across the paper from left to right with a wide, even stroke. Continue to paint horizontally down the paper, making sure that each new stroke runs through the wet paint at the bottom of the previous stroke.

GRADED WASH

For the graded wash, above right, mix four separate puddles of wash colour:
1 French Ultramarine mixed with a little Crimson Alizarin
2 Crimson Alizarin and Yellow Ochre
3 Yellow Ochre
4 Hooker's Green No. 1 and Yellow Ochre
Start your wash with the first colour mix, then dip your brush in the next colour and continue down until you have introduced all four colours, always making sure your brush is full of paint and that it touches the bottom of each previous wet brush stroke.

FILLING-IN STROKES

When filling in small areas of colour your brush strokes will need to go in different directions, see below left. This doesn't matter – if your brush is full of watery paint, the strokes will merge together. Of course, by watery, I don't mean wishy-washy! For stronger colour, simply add more paint to your mix.

PAINTING SHADOWS

One of the most important colour mixing lessons in this book is my shadow colour. I use various mixes of the same three colours for shadows. These are French Ultramarine, Crimson Alizarin and a touch of Yellow Ochre, plus plenty of water. Because watercolour is transparent, you can paint shadow colour over any colour once it has dried, as well as onto white paper, and it will give the effect of a shadow falling across it.

Graded wash

Filling-in strokes

Painting shadows

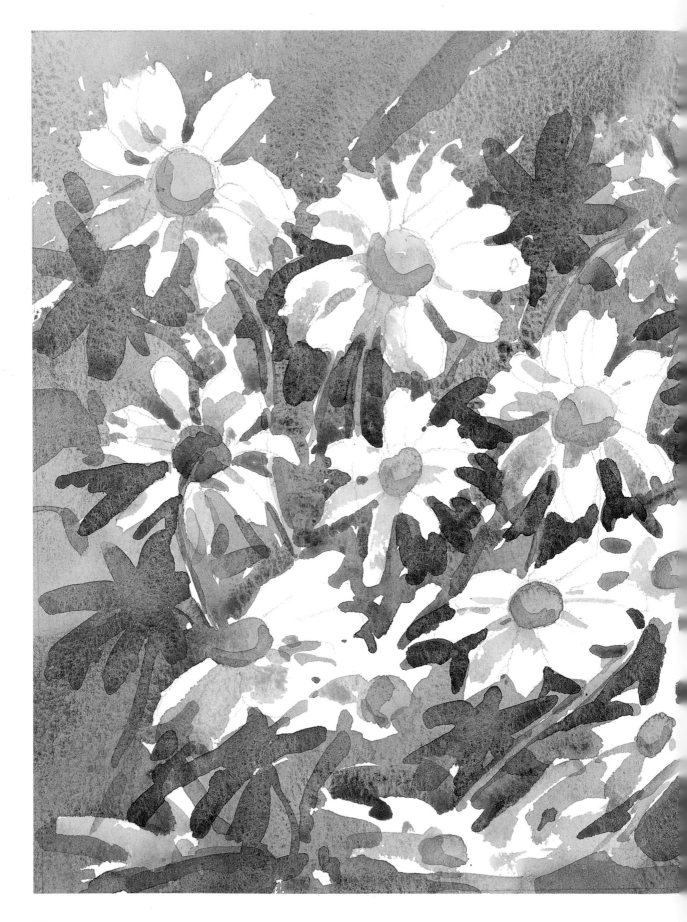

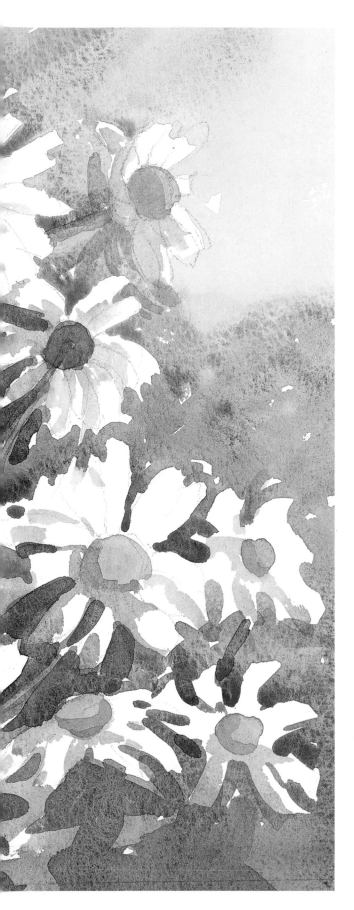

◆ *Flowers* ◆

My most important reason for choosing flowers as the first painting project in this book is their constant availability. Gardens, window boxes, hanging baskets and patio pots provide perfect painting opportunities. The countryside and parks also offer a wide range of flora and even in cities you can find wild flowers growing on building sites and in the mortar of brick walls. You can also buy cut flowers and house plants at any time of the year and this means you can get used to painting flowers at home to gain confidence before you venture outdoors.

Flowers are a joyous thing to look at and a great pleasure to paint. Unless you are doing a botanical painting, you can paint flowers more freely than many other subjects. It really doesn't matter if a petal is a different shape or a slightly different colour to the original, as long as the species of flower is recognizable from your painting.

◆ *Flowers* ◆
COLOUR MIXING

These exercises will help you mix some of the colours you'll need for leaves and flowers. Don't worry if you feel a little unsure at first. Keep your colours in the same position in your paintbox so you don't have to worry about looking for a particular colour when you need it. The more you practise colour mixing, the more you'll build up your confidence and enjoy your painting

In watercolour, colours are rarely as strong as in nature. To achieve a lovely watercolour look, always use plenty of water. When colour mixing, the most important thing to remember is that the predominant colour is the first one you use. For example, yellow and blue mixed together make green. If you want a yellowy-green, put yellow in the mix first and then add a smaller amount of blue to it.

1 *Make a colour mix of French Ultramarine, Crimson Alizarin with lots of water. Add more water to make it paler and more colour to make it stronger.*

2 *Mix Crimson Alizarin and Hooker's Green No. 1 with water. Add more green to make it greener and more red to make an autumn leaf colour.*

3 *Use Hooker's Green No. 1 with French Ultramarine, then add more green to make it greener and more blue with plenty of water to make a soft silvery colour.*

4 *Cadmium Yellow Pale mixed with French Ultramarine makes various shades of green.*

5 *Mix Cadmium Yellow Pale and Hooker's Green No. 1 with plenty of water. Add more yellow to make a spring green, or more green to make a very bright green.*

6 *For the pink flower, mix Cadmium Red with Yellow Ochre and plenty of water – you only need a touch of each colour.*

7 *Mix Cadmium Yellow Pale and Yellow Ochre with plenty of water for the yellow flower. Add more Yellow Ochre for the stronger colour in the centre of the petals.*

8 *For the red flower, mix Cadmium Red with Crimson Alizarin and plenty of water.*

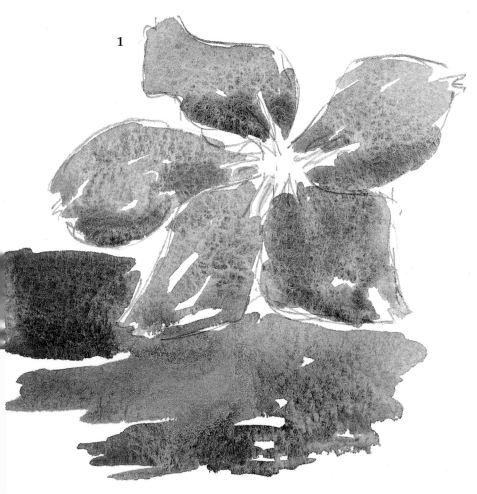

1

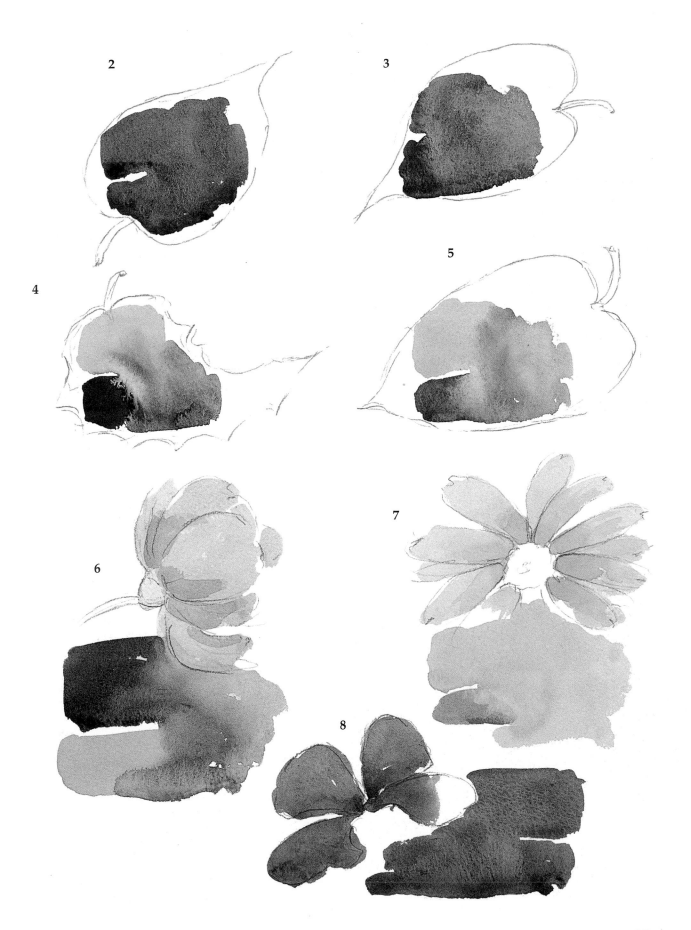

◆ *Flowers* ◆
PENCIL SKETCHING

If you are wondering why you should learn to sketch when you really want to paint, remember that you will usually need to draw your subject before you paint it. Sketching is also a wonderful way of getting the feel of a subject because you really have to concentrate. You'll quickly learn if a particular flower has a thick or thin stem and understand its petal and leaf shapes. Your sketch doesn't have to be absolutely perfect – just try to get the essence of the flower. If it's fragile, don't use strong lines or heavy shading. If it's thick and solid, use heavier lines.

If you find drawing difficult, take heart. This was one of my weak points at first but, after plenty of practice, I can now tackle most subjects with confidence.

USING YOUR PENCIL

First learn what your pencil can do for you. I always use a 2B pencil on cartridge paper. Experiment with different pencil lines and shading by copying my examples below.

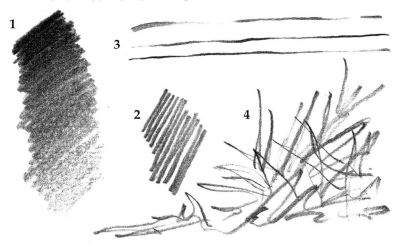

Nicotiana
Cartridge paper
17 × 9 cm (7 × 3½ in)
These flowers have very definite starfish-shaped petals. Don't press your pencil too hard but be firm. There are lots of short, straight positive lines for the tube part of the flower. Remember this is just an outline drawing.

1 *Shading with a 2B pencil, going from heavy to light pressure.*

2 *Pencil lines are dark when pressure is put on the pencil and light with the pressure taken off.*

3 *Straight lines are normally used for formal shading, such as in buildings or boats.*

4 *Use scribbly lines for grass, hedges, and in general landscape.*

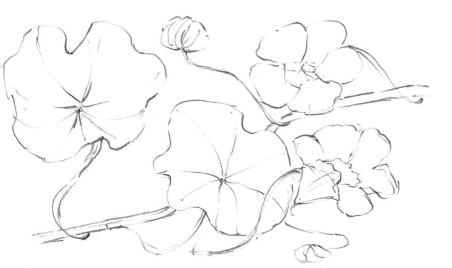

◀ *Nasturtium*
Cartridge paper
11 × 16 cm (4½ × 6½ in)
Your pencil will flow more when you sketch these nasturtium flowers and leaves because they are made up of curves. The main stem is important because you draw all the other stems out from it. Lift your pencil almost off the paper at times to get the feeling and movement of the leaves.

SIMPLE OUTLINE SKETCHES

When you start sketching, aim for the simple outline shapes of the flowers and leaves. I suggest that you copy my examples of the nicotiana, nasturtium and rose but don't put in any shading yet. Do lots of sketches like these before you go on to the next exercise.

ADDING LIGHT AND SHADE

After practising simple shapes, start adding some pencil shading to your flowers as I have with the geranium flowers, below.

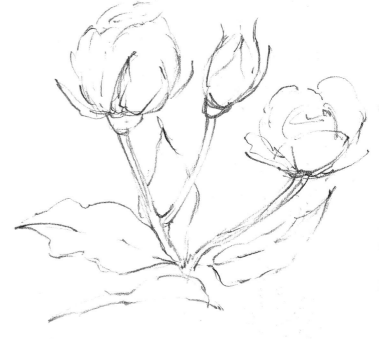

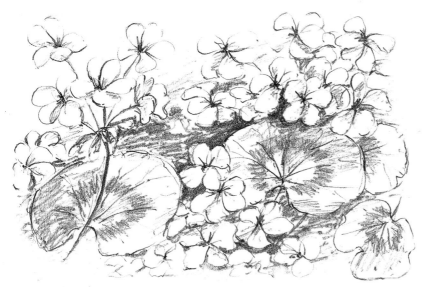

▲ *Rose*
Cartridge paper
10 × 11 cm (4 × 4½ in)
Draw heavier pencil lines for the cups and stems of the roses.

◀ *Geranium*
Cartridge paper
11 × 16 cm (4½ × 6½ in)
This geranium has lots of small, delicate flowers. Draw them fairly freely using more pressure on the pencil for the flower centres. Making the areas between some of the flowers darker gives depth to the drawing.

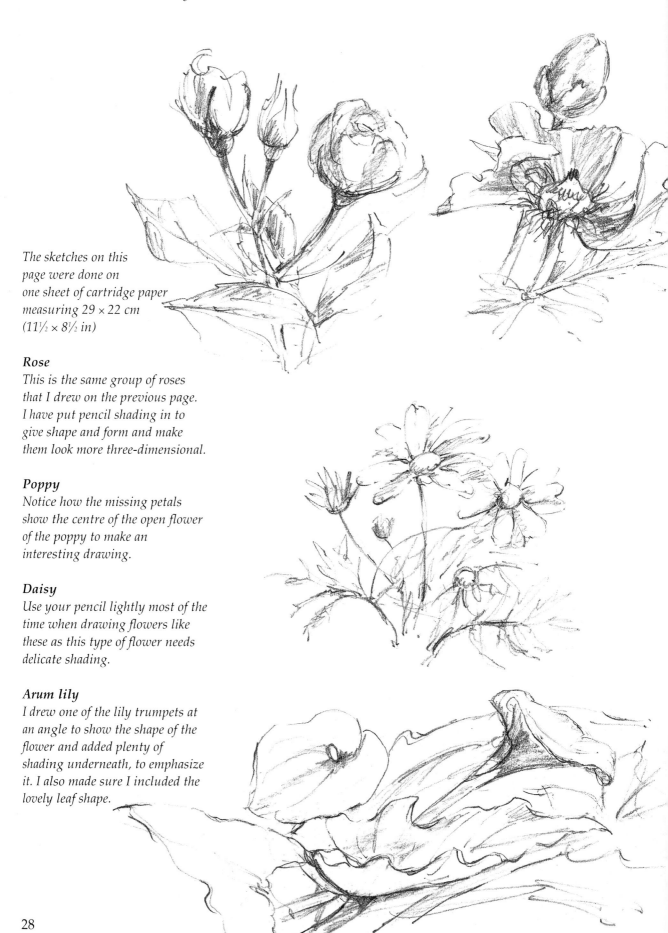

The sketches on this
page were done on
one sheet of cartridge paper
measuring 29 × 22 cm
(11½ × 8½ in)

Rose
This is the same group of roses
that I drew on the previous page.
I have put pencil shading in to
give shape and form and make
them look more three-dimensional.

Poppy
Notice how the missing petals
show the centre of the open flower
of the poppy to make an
interesting drawing.

Daisy
Use your pencil lightly most of the
time when drawing flowers like
these as this type of flower needs
delicate shading.

Arum lily
I drew one of the lily trumpets at
an angle to show the shape of the
flower and added plenty of
shading underneath, to emphasize
it. I also made sure I included the
lovely leaf shape.

◆ *Flowers* ◆

PAINTING WITHOUT DRAWING

Now, in complete contrast to the last exercises, I want you to try your hand at painting without drawing! Putting paint onto a blank piece of paper is undoubtedly the most frightening thing for anyone starting to paint. However, since you won't have to worry about keeping your colours carefully within drawn pencil lines, this will really help build up your confidence. It's also great fun because it gives you the freedom to experiment with colours and brush strokes, while relaxing and letting the colours flow.

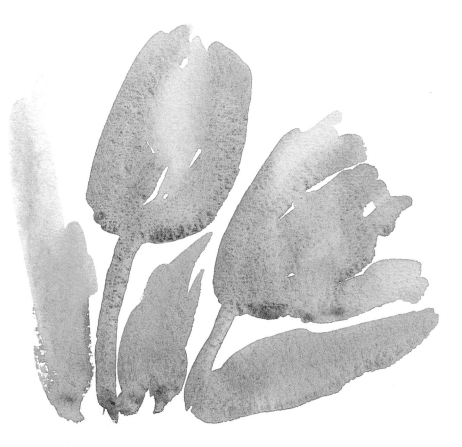

Tulip
Bockingford 200 lb
16 × 16 cm (6½ × 6½ in)
Cadmium Red was painted either side of Yellow Ochre in the first tulip and luckily it stayed that way. What would a watercolourist do without the occasional 'happy accident'! The red ran into the green stems but it didn't matter. Let your colours run freely and enjoy this kind of painting practice.

Simply look at the flower shapes and colours and 'whoosh' the paint on the paper. That's my word for using a paint-loaded brush very freely – it describes it perfectly! I have used Bockingford watercolour paper for these exercises – the flowers on the opposite page were all done on one sheet of Bockingford 200 lb – but you could use cartridge paper for this exercise if you wish. When you have more experience you can experiment by using many different papers. But for now just enjoy putting paint on paper and don't worry about a thing.

By painting freely in this way you will feel how the paint flows out of the brush onto the paper. It will also help you to control your brush and make the shapes you want, as well as taking away your fear – particularly since you aren't trying to paint a finished picture! Everyone will know that you are simply practising. Having said that, I must admit I love some of the paintings I have done this way because of their freedom.

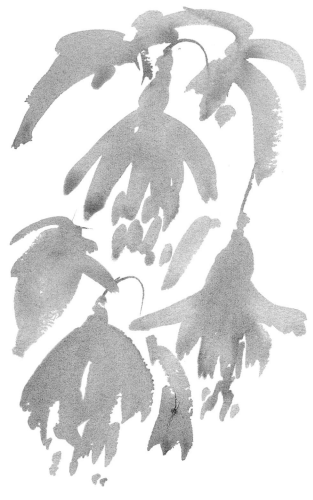

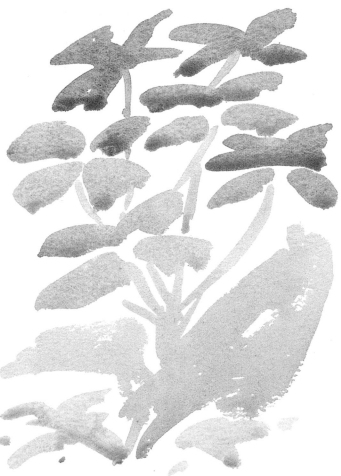

▲ *Fuchsia*
Bockingford 200 lb
17 × 14 cm (7 × 5½ in)
These flowers have lovely shapes to paint. All the brush strokes are downwards, which means the colours run down beautifully and the whole thing has movement.

◀ *Geranium*
Bockingford 200 lb
20 × 12 cm (8 × 5 in)
Paint the blue flowers. Then run the stems from the flowers while they are wet.

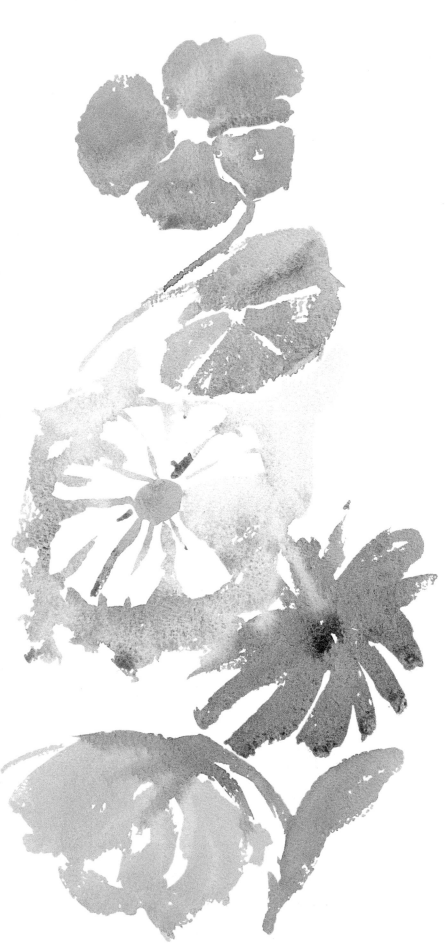

The flowers on this page were
painted on Bockingford 200 lb
38 × 20 cm (15 × 8 in)

◄ Nasturtium

Just flow your colours together
but leave the centre of the flower
as white paper and thin white
lines of paper showing to define
the petals and leaf.

◄ Daisy

Paint the background colour
leaving petal shapes, then drop
yellow into the centre of the daisy
while the paint is still wet. Don't
worry if the paint runs because
this will help the effect.

◄ Chrysanthemum

Let your brush strokes form the
petals. Drop a small amount of
blue in the centre of the flower
while it is still wet.

◄ Rose

'Whoosh' on colour for this yellow
rose, then add the green while it is
still wet. If it runs, don't worry!

◆ *Flowers* ◆
WATERCOLOUR SKETCHING

There are several good reasons to take your paints and sketchbook outside to do watercolour sketches. Naturally, you will be learning how to cope when painting outdoors, but at the same time you will be gathering information to use when working indoors. Of course, a watercolour sketch can also be a painting in its own right. Some of the watercolour sketches I have done on these pages would make nice little paintings, especially if they were framed – in fact, a sketch can sometimes be better than a more 'finished' painting. One tends to tighten up when trying to paint a masterpiece but, if a sketch goes wrong, you know you are only practising, so it doesn't matter! It's a great confidence-builder.

Fuchsia
Cartridge paper
14 × 11 cm (5½ × 4½ in)
The flowers were Crimson Alizarin and Yellow Ochre and plenty of water. I used the same colour for the leaf centres, with Yellow Ochre and Hooker's Green No. 1 on either side. When they were dry, I put on the shadows with a mix of French Ultramarine, Crimson Alizarin and a touch of Yellow Ochre.

SMALL FLOWER SKETCH

This little sketch was done in my garden, on a lovely summer's day. I painted it on cartridge paper in my sketchbook. Incidentally, when working directly in the sun, your paint will dry very quickly. This is an advantage when you want it to dry so you can apply another wash over it, but a disadvantage when you are working wet-in-wet paint. I didn't want my paint to dry too quickly when I painted the periwinkle on the next page because I wanted the blue to merge into the crimson – so I made sure I wasn't sitting in the sun. If you have to work in the sun, use more water and work quickly. Draw your flowers first, shading them if you wish as you did in the pencil sketching exercises, and then paint them very freely.

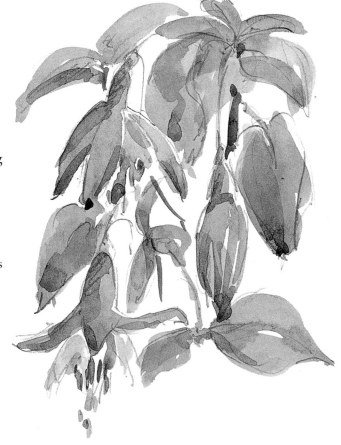

PERIWINKLE

This periwinkle made a very simple but charming flower sketch. Practise doing small sketches like this; it will give you the confidence to tackle larger flower paintings.

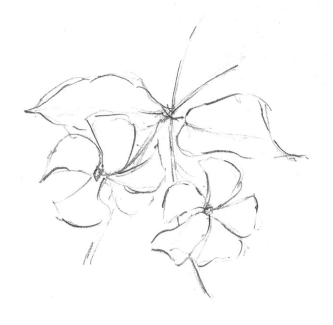

◀ STAGE 1
Draw the flowers the same size as they are reproduced here, using a 2B pencil on cartridge paper.

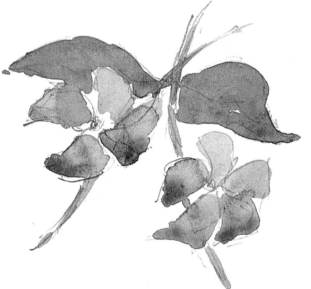

◀ STAGE 2
Paint the petals using French Ultramarine and Crimson Alizarin and letting the colours run into each other on the paper. Paint the leaves with a mix of Hooker's Green No. 1, a touch of Yellow Ochre and Crimson Alizarin. Don't worry if your paint runs a little – mine did!

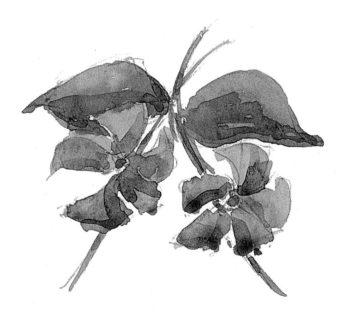

◀ FINISHED STAGE
Cartridge paper, reproduced actual size
Dot fairly strong Yellow Ochre into the centre of each flower. When this is dry, mix French Ultramarine, Crimson Alizarin and a touch of Yellow Ochre, plus plenty of water, and use this to paint shadows onto the leaves and petals.

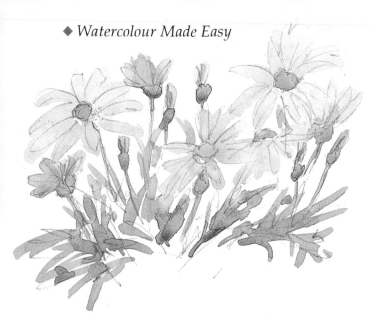

◀ **Cornish Gold**
Cartridge paper
10 × 12 cm (4 × 5 in)
These little yellow flowers were very delicate. I didn't overwork them, otherwise they would have lost their fragile look.

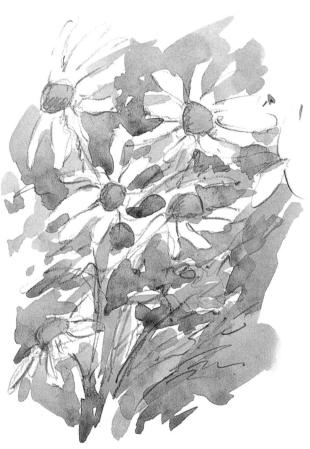

▶ **Daisies**
Cartridge paper
12 × 10 cm (5 × 4 in)
These too were a mass of fairly delicate leaves and flowers. Don't worry if colour runs but make sure you leave the petals as unpainted white paper.

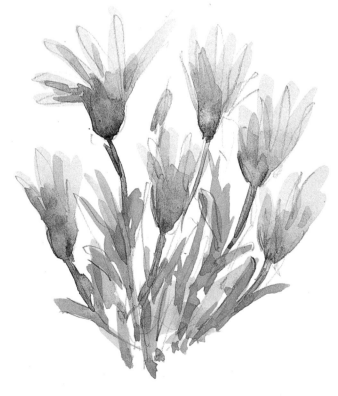

◀ **Rain daisies**
Cartridge paper
12 × 11 cm (5 × 4½ in)
I had to stand in a rather uncomfortable position to paint these flowers, which meant I had to work fast. This can be an advantage, since you don't have time to fiddle. When you paint them, let the pink flowers dry before you put on the bluey colour.

TUMBLING TED

◀ STAGE 1

The drawing in this demonstration has to be done more carefully than the one on page 33. Because you are painting a dark background up to the light-coloured flower shapes, you need a drawn line to paint up to.

◀ STAGE 2

Paint the flowers with a very watery Crimson Alizarin, dropping a fairly strong dot of colour into the middle of each flower while it is still wet. Then paint the leaves in freely, adding a few more here and there.

◀ FINISHED STAGE

Bockingford 200 lb
40 × 15 cm (16 × 6½ in)
Put the background in with free brush strokes, changing the colour as you go. Use mixes of French Ultramarine, Crimson Alizarin and a touch of Yellow Ochre. Don't worry if you go over some of the leaves or change their shapes. This stops a painting looking tight and mechanical. Above all, enjoy it – remember you are still practising!

◆ *Flowers* ◆
DEMONSTRATION

It is vital to establish a centre of interest when painting a complicated subject like these nasturtiums. I've picked out some flowers and leaves that are more important in colour and size, so your eye comes to rest on the two large orange flowers. The smaller flowers, lower left, lead you into the picture, while the large flower, top right, catches your eye on the way up and sends it down to the central yellow flower.

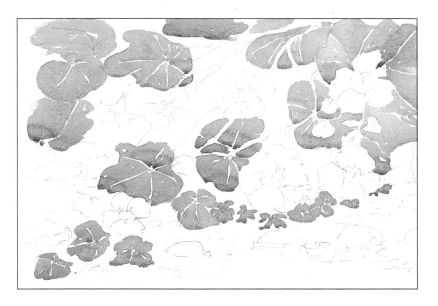

◀ STAGE 1
Draw the picture and then mix three puddles of paint: Hooker's Green No. 1 with French Ultramarine, then Hooker's Green No. 1 with Crimson Alizarin and finally Hooker's Green No. 1 with Yellow Ochre. Paint in the leaves, varying the greens and leaving white paper for veins. Painting the leaves first will make it easier for you to see what to paint next.

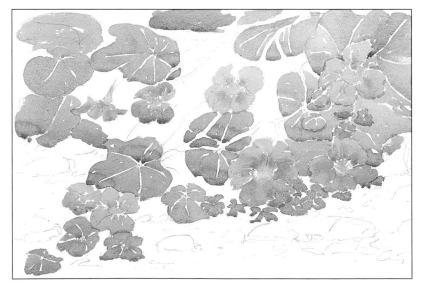

◀ STAGE 2
Mix a puddle of Yellow Ochre and a puddle of Cadmium Red. Paint the orange flowers with Cadmium Red and Yellow Ochre, letting these colours run together in places. Drop a touch of Crimson into the wet paint in places. The yellow flowers are Yellow Ochre with a touch of Cadmium Yellow and a touch of Crimson Alizarin near the centre.

▶ STAGE 3

Mix two puddles: one of French Ultramarine and Crimson Alizarin with a touch of Yellow Ochre and one of Hooker's Green No. 1 with Crimson Alizarin. Leaving white paper for the stems, paint in the background using the first colour mix to start with and adding the second paint mix here and there. Then mix Crimson Alizarin and Yellow Ochre and paint the stones using the background colours for variation.

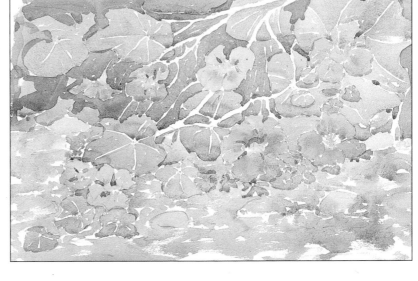

▶ FINISHED STAGE

Nasturtiums
Bockingford 200 lb
38 × 56 cm (15 × 22 in)
Mix French Ultramarine, Crimson Alizarin and a little Yellow Ochre and paint shadows on the leaves, flowers, stems and some stones. Don't get too fussy – leave the foreground fairly simple or the eye will be drawn to the stones instead of the flowers.

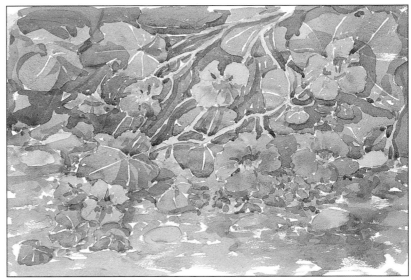

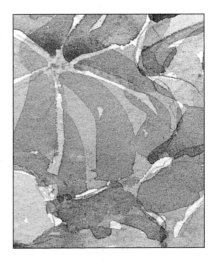

CLOSE-UP DETAILS

◀ *The simple shadows and the variations in colour give depth and shape to the flower.*

▶ *Notice how the white paper in the veins on the leaves shows through the shadow colour. Again shadows give shape and depth to the painting.*

◆ *Flowers* ◆

Working from a Photograph

It is perfectly acceptable to paint from a photograph but, before you start, always study the one you are going to use carefully to see if it will make a painting. Leaving out unnecessary clutter often makes a better picture so concentrate on what interests you most about the photograph and why you want to paint it. I was attracted by the sunlight and deep shadows on the lilies in this photograph and my painting has emphasized these things.

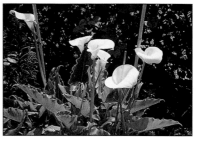

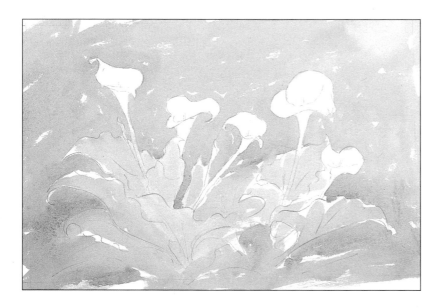

◀ Stage 1

Draw in the flowers and main leaves. Mix individual puddles of Yellow Ochre, Cadmium Yellow, Hooker's Green No. 1, French Ultramarine and finally one of French Ultramarine, Crimson Alizarin and a little Yellow Ochre. Paint a wash freely all over the paper. Make it predominantly yellow, but work in the other colours here and there as you paint down. Leave the flowers as white paper. Paint some yellow into the leaves and let it dry.

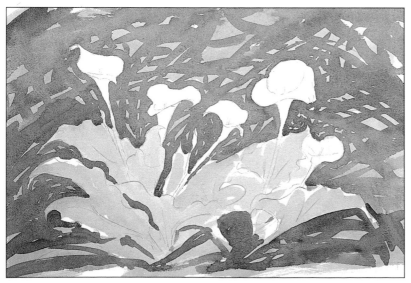

◀ Stage 2

Use the same colour mixes but stronger – try them out on a spare piece of paper first. Paint over the first wash but leave some areas showing through to suggest sunlight. Let your brush dance around – don't try to copy me exactly or you'll lose the freedom you need for this type of painting. Leave the flowers and leaves unpainted.

▶ **STAGE 3**

Paint the flower stamens in Yellow Ochre and run some of that colour into the trumpets under the petals.

Mix a soft shadow colour with French Ultramarine, Crimson Alizarin and a touch of Yellow Ochre. Paint the shadows inside the flowers, starting very pale and watery at the top but getting stronger near the stamen. The shadows under the petals on the trumpets shouldn't be too heavy; you can always add more darker tones later.

Then, with a mix of Hooker's Green No. 1 and Yellow Ochre, paint the stems and leaves again but leave some of the yellow underwash showing through.

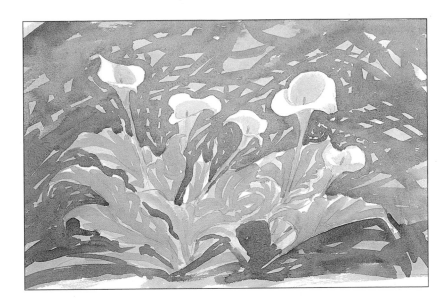

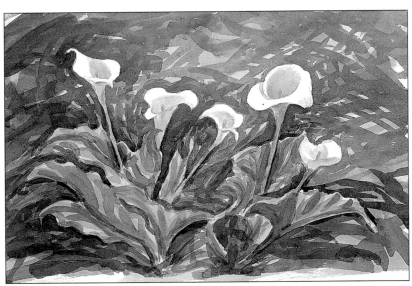

▲ **FINISHED STAGE**
Lilies
Bockingford 200 lb
38 × 56 cm (15 × 22 in)
Mix three separate puddles of colour in your palette: French Ultramarine and Hooker's Green No. 1; French Ultramarine with Crimson Alizarin and a touch of Yellow Ochre, and Hooker's Green No. 1 and Crimson Alizarin.

Paint the darker green on the leaves, leaving some of the underpainting showing. Make your brush strokes dance, putting darker colours where you feel they are needed on the background – notice how the darks in my painting help to bring out the shapes of the leaves and the flowers.

When it is dry, paint a wash of Yellow Ochre over the sunny area at the top of the painting. Put some on the leaves, and light touches on the flowers to add sunlight. You won't be able to copy all my brushstrokes – don't even try. Just let your brush move freely around and simply enjoy it.

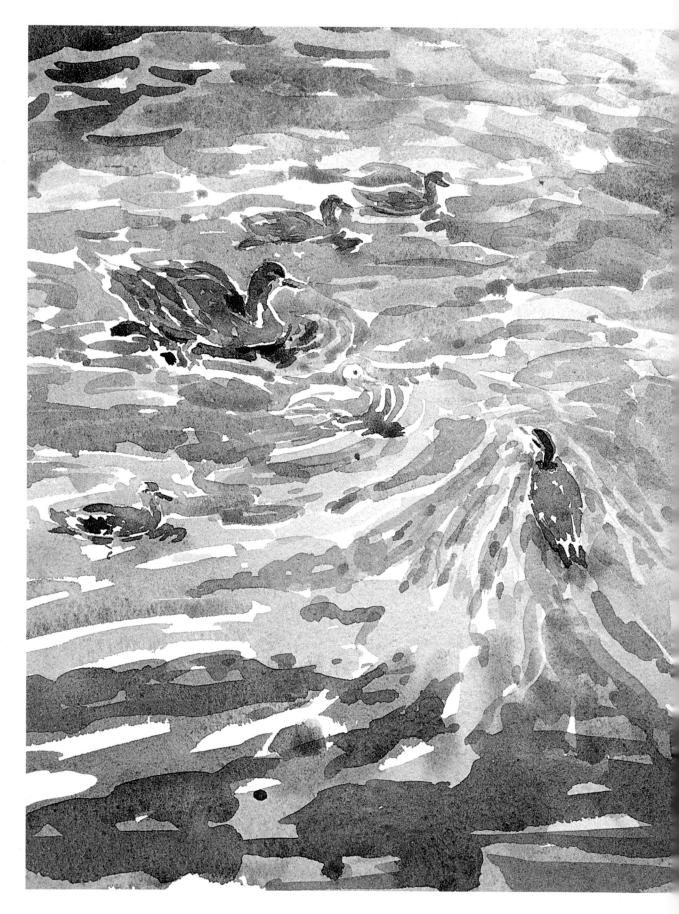

◆ *Ducks & Chickens* ◆

Watching ducks and chickens can be extremely enjoyable and I love drawing and painting them. They can be really comical and, where possible, I like to put humour into my paintings. Mind you, they can be frustrating, particularly when ducks tuck their heads under their wings or chickens rush about, making it hard to concentrate and get started! But it is always well worth the time and effort and they make lively and colourful paintings. In fact, you will probably be surprised at the amount of different colours you use, especially when painting cockerels.

You can also use ducks or chickens to add colour and life to the foreground of some of your landscape paintings.

◆ *Ducks & Chickens* ◆
COLOUR MIXING

Female ducks are usually brown or white and brown ones have patterns in different browny hues all over them. Their beaks are yellowy-orange, sometimes with some dark colour on them, and their legs and feet are a bright reddy-orange.

The feet and legs of drakes are often the same colour as the female, but male beaks are usually a very pale yellow. Unless they are a special breed, drakes' heads are usually various mixtures of dark bluey-green, deep purple, dark blue and different shades of dark brown, often separated from their chests by a thin band of white. Their chests can be brown, grey or white. Drakes often have very dark tail feathers.

Practise these colour mixing exercises and study ducks and drakes carefully when you can. You will soon get used to their different colours and markings.

1 *Use a fairly strong mix of French Ultramarine, Crimson Alizarin and Cadmium Yellow for the dark grey head, with lots of water for the paler body.*

2 *French Ultramarine, Crimson Alizarin and Yellow Ochre can make lots of shades of grey and I always use this mix for shadows (see page 21). Without it, you won't be able to give form to white ducks.*

3 *Use a mix of Hooker's Green No. 1 and French Ultramarine to make some of the greens you find on a drake's head.*

4 *This white duck's beak is Cadmium Red and Yellow Ochre with more Yellow Ochre, while the legs have more red in the mix.*

5 *Mix Cadmium Red, French Ultramarine and Yellow Ochre to make a good base for the female duck.*

6 *Use Cadmium Yellow with plenty of water to paint the drake's beak.*

7 *Mix Crimson Alizarin, French Ultramarine and Yellow Ochre to make various shades of deep brown for the duck or drake's chest.*

8 *Use a mixture of Crimson Alizarin and French Ultramarine for the deep purple found on some drakes' heads.*

1

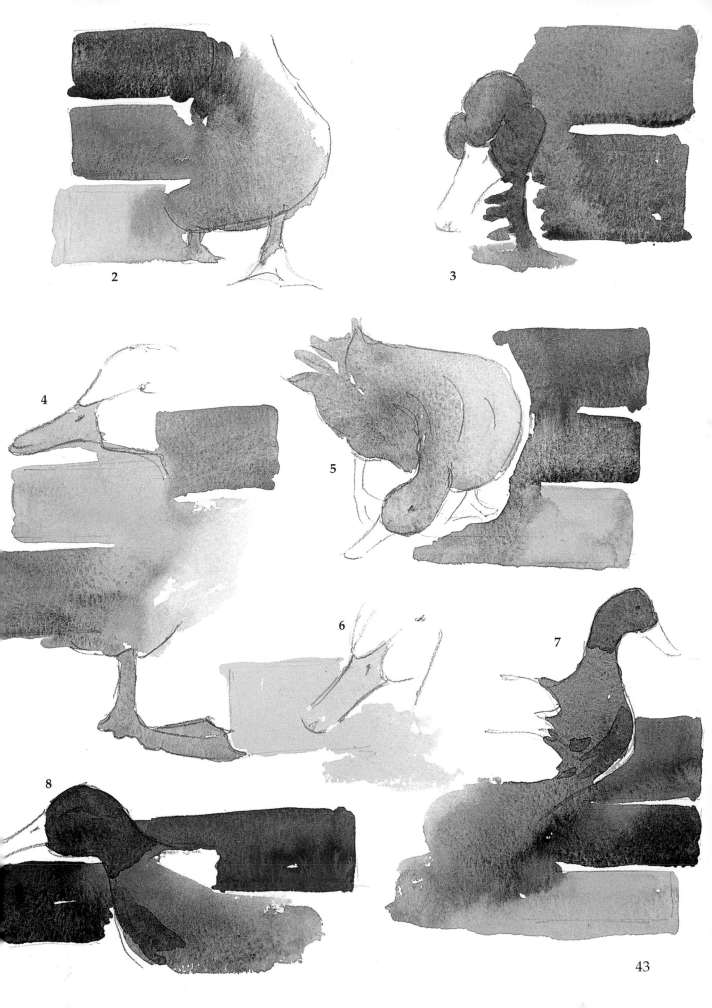

2

3

4

5

6

7

8

◆ *Ducks & Chickens* ◆
PENCIL SKETCHING

To sketch ducks outside, especially when they are feeding, is a fantastic experience. They are just like vacuum cleaners and, as you watch them dart around you will find your pencil starts to move faster and faster! Speed is the only way to capture their movements. Don't worry if your first pencil marks are just scribble to begin with – gradually they will start to resemble ducks, and then you will feel wonderful.

FIRST PENCIL SKETCHES

Practice is the only answer to drawing live ducks. Some will stand still for you for a few seconds, if you are very lucky!

 Try to get the overall shape of the duck to start with, beginning with the head. Then look at how the beak fits into the head, where the eyes are placed, how the neck goes into the body, how far

Cartridge paper
28 × 42 cm (11½ × 16½ in)
Just sketch the outline of the ducks to begin with. The important thing is to try and get the overall shapes.

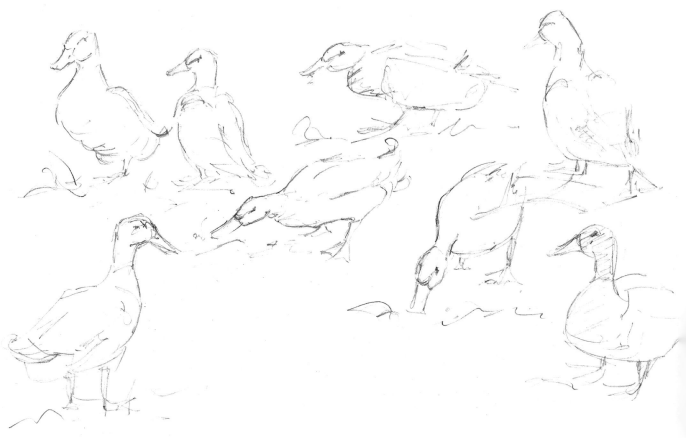

44

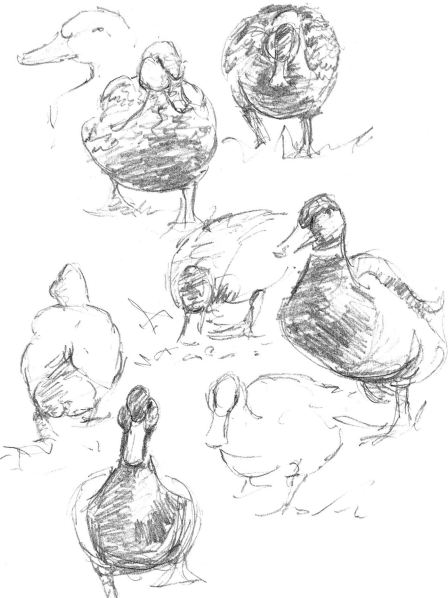

◄ Cartridge paper
28 × 17 cm (11 × 7 in)
I have shaded these ducks to make them look more three-dimensional. This is the next stage. It takes quite a while to get to grips with the shading as well as the drawing because ducks are moving all the time. Half-close your eyes and you will see where the darkest and the lightest parts of the duck are. Leave the lightest as white paper and shade in the darkest part by putting more pressure on your pencil.

▼ Cartridge paper
14 × 9 cm (5½ × 3½ in)
The light was coming from the right so, although the drake had a dark-coloured head, neck and chest and a pale-coloured lower body, I have left the light on the right side of the chest and shaded the left side of the lower body because it is in the shade.

apart the legs are and so on. These details will help you to draw a duck that looks like a duck. Sketch quickly to get movement into your drawing and don't worry if your pencil lines sometimes go the wrong way.

If the duck you are drawing moves away, start sketching another. If you see a new duck in the same position as one of your unfinished sketches, carry on using that one as your model. Many of my ducks are composite ones! To help you learn about drawing ducks, you can study or try copying your own photographs and videos. Bird identification books can also be helpful as a reference. But remember, for best results, you should work from life as much as possible.

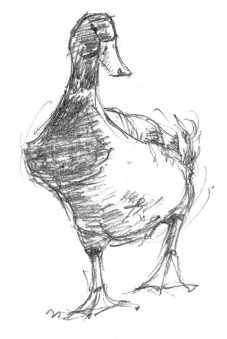

◆ *Ducks & Chickens* ◆
PAINTING WITHOUT DRAWING

Painting ducks without drawing them first will really help your brush capture their movements. I painted the ducks on the opposite page with my No. 10 brush and used a large sheet of paper so that I could let the paint flow freely. It was really exciting to see the colours run into each other as they formed the shapes of the ducks. Where you don't want colours to run into each other, leave a thin white paper line between them. Look at the duck at the bottom of that page and you will see that there is a thin white line dividing the head from the body.

I love the jaunty drake running towards us. The brush strokes I used to paint the shape of his body left white paper highlights and were very freely done. His legs were painted with single brush strokes.

▶ Bockingford 140 lb
50 × 38 cm (20 × 15 in)
Notice how freely these ducks are painted – they really do have plenty of movement. Don't be too concerned about detail and shape. The beak on my duck at the bottom of the page looks more like a shovel but it really doesn't matter for the purpose of an exercise like this.

◀ Bockingford 140 lb
15 × 15 cm (6 × 6 in)
Use your No. 6 brush and just let the colours flow. You can 'whoosh' more colours on while the others are still wet. Don't worry if they run as the yellow beak did on the green head of the drake here. You want to get the feel of the paint and brush so that you can make the shapes you want. The white duck is suggested by a soft shadow colour.

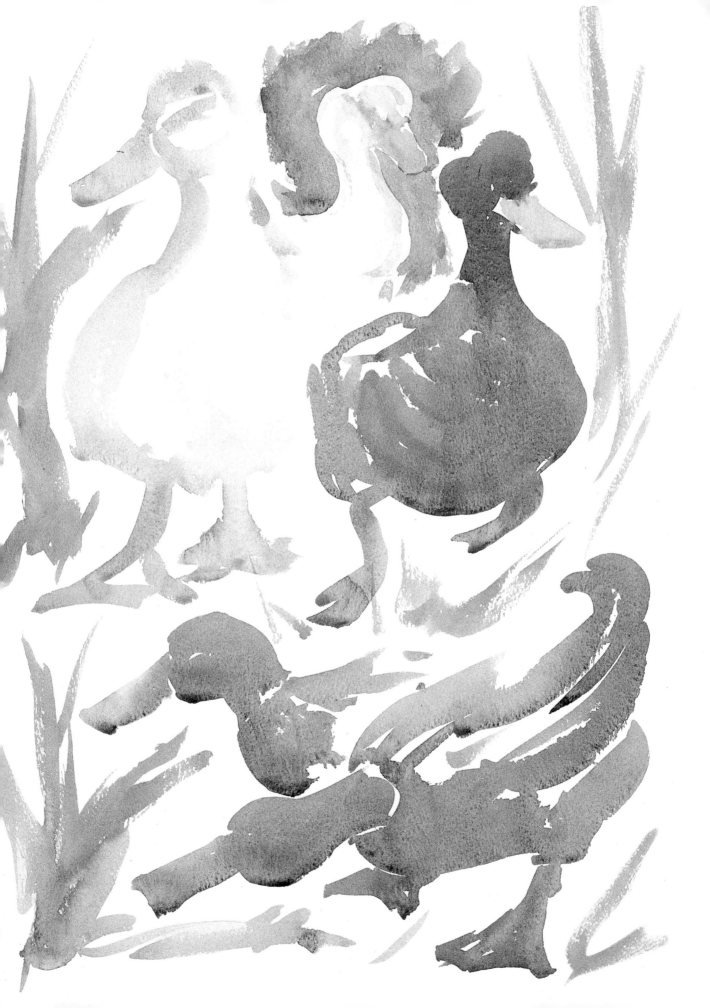

◆ Ducks & Chickens ◆
WATERCOLOUR SKETCHING

These ducks were watching me warily from a distance to begin with but, as soon as I threw down some food, it was like the rush hour and they were all around my feet in a frenzy of activity! I sketched them first in pencil but this didn't have to be too detailed because I was going to use brushstrokes to carry on where my pencil left off. Of course, ducks generally won't pose for longer than a few seconds, so you must make sure you mix most of the colours before you start painting. Indeed, they may suddenly fly away! This can be very frustrating but remember that, as with pencil sketching, you can use several ducks as one model.

Cartridge paper
29 × 20 cm (11½ × 8 in)
As with pencil sketching, it can take time to get into the flow of sketching with paint. Sometimes it is twenty minutes or longer before my brush and brain start working together. The first duck has hardly any definition; the second one is in a better position to show form. The drakes are a little more defined – I had two attempts at the first one. The other two drakes have worked well because form has been suggested by exaggerating the light and shade.

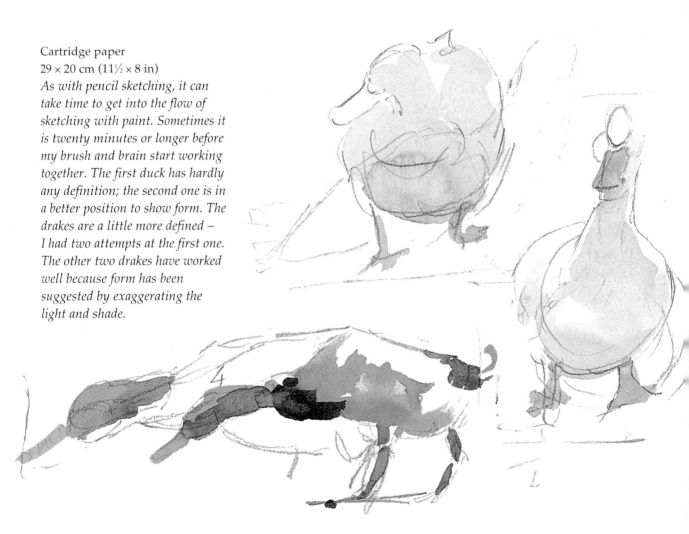

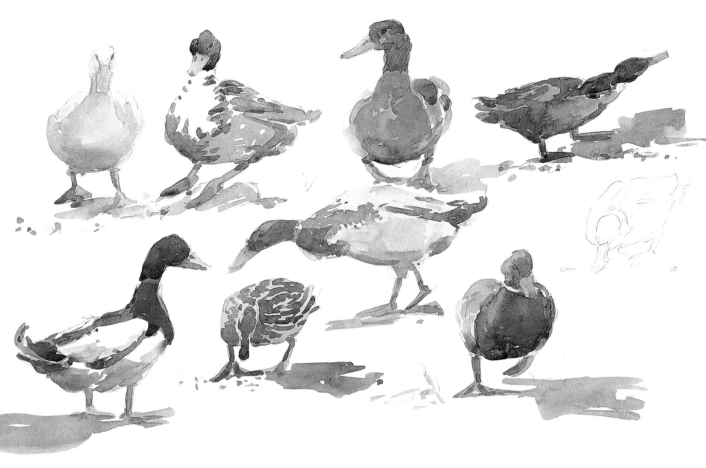

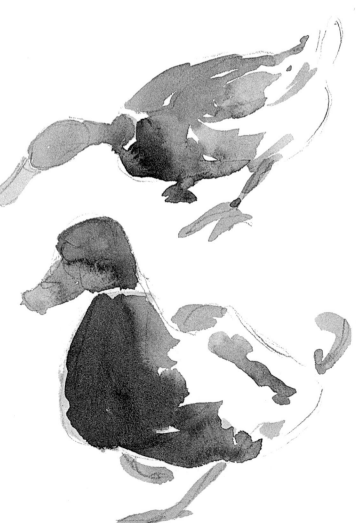

▲ Cartridge paper
28 × 42 cm (11½ × 16½ in)
Once you get into the flow of working, your watercolour sketches of ducks will become more controlled. Notice that, since a white duck would disappear on white paper, my one here has reflected colour from its beak and legs, and shadow colour elsewhere. The drakes' heads are different colours – the white bands around their necks are very helpful for stopping colour running. Shadows, like the shading in pencil drawing, help to make ducks look three-dimensional. They also suggest sunlight and help to anchor an object to the ground – in fact, shadows can really pull a painting together.

DEMONSTRATIONS

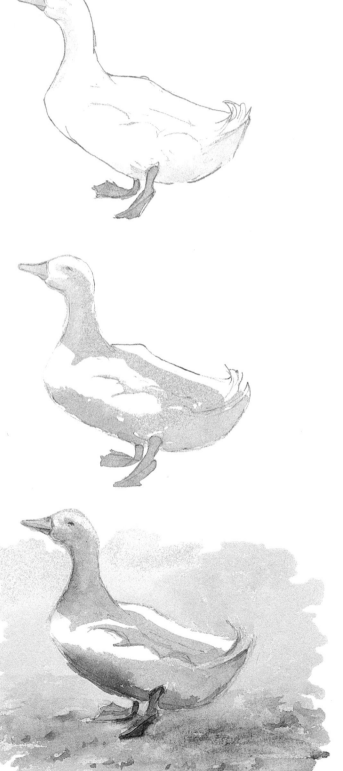

DUCK

◄ STAGE 1

Sketch the duck, then use your No. 6 brush to paint the beak with Yellow Ochre. Add more water and paint the underside of the neck. Paint the legs and feet with Cadmium Red and Yellow Ochre, and add more water for the undercarriage.

STAGE 2

Mix shadow colour with French Ultramarine, Crimson Alizarin and a touch of Yellow Ochre and, when the first stage is dry, paint the neck and continue over the back and underneath the duck.

FINISHED STAGE

Mix a wash of Yellow Ochre with a touch of Crimson Alizarin and lots of water. Paint around the head and neck with this watery mix but make it stronger as you work down into the ground. Add some of the shadow colour on the ground while it is still wet.

Let the paint dry. Using the same shadow colour, paint under the beak, the neck and lower body. Work shadows on the legs and feet. Paint the eye in the same colour and finally put the shadows on the stones.

◄ FINISHED STAGE

Bockingford 200 lb
45 × 22 cm (18 × 8½ in)

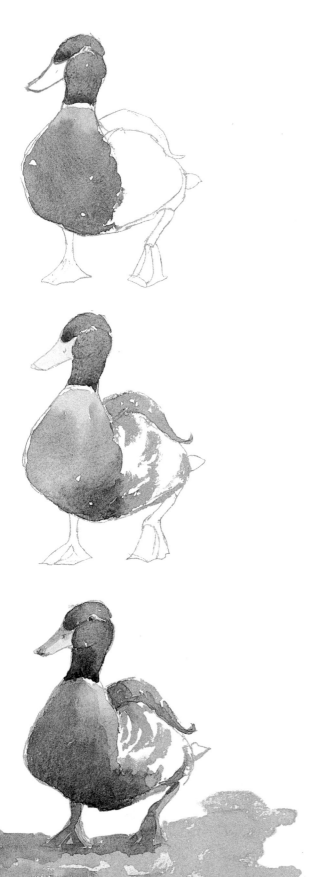

DRAKE

◀ STAGE 1
Draw the drake and then, again using your No. 6 brush, paint the head with Hooker's Green No. 1, Cadmium Yellow Pale and French Ultramarine. Let the colours run together in places. Leave a thin line of white paper and paint the rest of the neck with Yellow Ochre running into a mix of Crimson Alizarin, Yellow Ochre and a touch of French Ultramarine down the chest.

◀ STAGE 2
Paint the beak with Cadmium Yellow Pale. Use the same mix as you did for the chest to paint the rest of the body. Vary the colours and work the brush strokes in the direction of the feathers.

FINISHED STAGE
Now paint the feet with a mix of Cadmium Red and Yellow Ochre. When this is dry, use Yellow Ochre, Crimson Alizarin and a touch of French Ultramarine to paint in the ground. Paint shadow colour on top of the beak, under the neck, on the chest, feet and undercarriage. When dry, paint the shadow the drake has cast on the ground.

 The final touch is to paint in the eye. Notice how the drake comes to life when you do this.

◀ FINISHED STAGE
Bockingford 200 lb
45 × 22 cm (18 × 8½ in)

◆ *Ducks & Chickens* ◆
WORKING FROM A PHOTOGRAPH

This is one of those rare photographs that can be painted just as it is. Naturally, you shouldn't try to copy everything in it or you will lose the freshness and spontaneity. I have kept my painting simple and left plenty of white paper to make the water sparkle. The colour of the water should be in keeping with the ducks so, if your ducks are paler than they are in the photograph, keep the water paler. If they are darker, paint it darker.

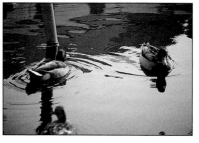

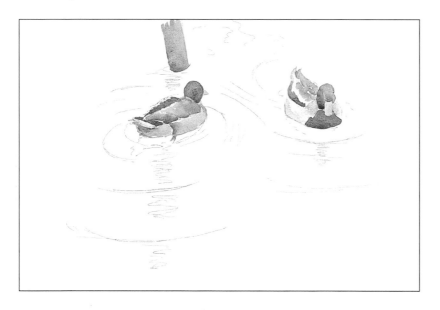

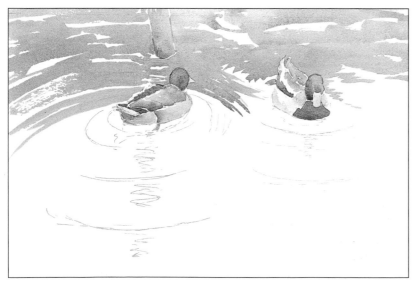

◀ STAGE 1

Draw the scene with pencil. Use your No. 10 brush to paint the post with Yellow Ochre on the right going into shadow colour on the left. Then use your No. 6 brush to paint the ducks' heads with a mix of Crimson Alizarin and French Ultramarine.

Paint the right side of the right duck's chest with a mix of Crimson Alizarin and Yellow Ochre. Add French Ultramarine for the darker side. Now, using the same colours – but sometimes with more French Ultramarine or more Yellow Ochre – paint the rest of the ducks' bodies. Look at my painting to see where these colours are used.

◀ STAGE 2

Now to paint the water. Mix one puddle of Crimson Alizarin, French Ultramarine and a touch of Yellow Ochre, and another of Hooker's Green No. 1 and Crimson Alizarin. Use your No. 10 brush and start painting the water from the top with your first mix, then run it into the second mix.

Don't try to copy me exactly but aim for a similar free and watery-looking effect. You are creating a painting and so it is an impression of water that you are after. If you compare the water in my painting to that in the photograph, you will see the difference.

▶ STAGE 3

Paint a shadow on the pole and paint its reflection in the water. Suggest movement by breaking the reflection up with short brush strokes.

Now paint the reflections of the ducks using soft, warm colours for the left-hand duck and darker colours for the right-hand one. Let these dry before you paint the ripples (rings) on the water. Use your two water colours again, adding some of the dark reflection colours in places. Paint the rings freely with your No. 10 brush.

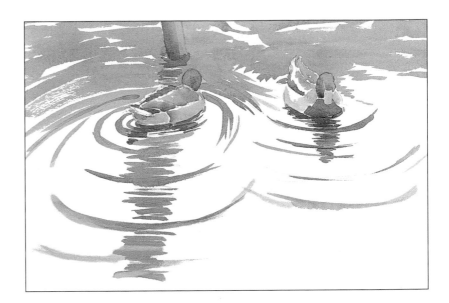

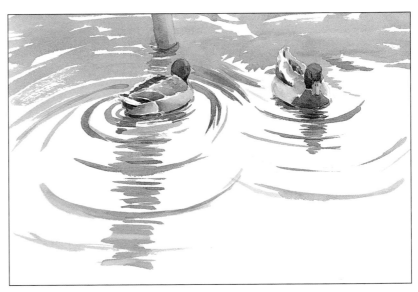

▲ FINISHED STAGE

Bockingford 200 lb
38 × 56 cm (15 × 22 in)
Use your No. 10 brush and a mix of French Ultramarine, Crimson Alizarin with a touch of Yellow Ochre to paint a dark shadow on the heads of the ducks, leaving some light areas.

Then, using the same mix, paint in the dark areas on and underneath both ducks. Add more water to this colour mix and paint shadows on the beak of the right-hand duck as well as on its chest and left side.

Finally, look carefully at your painting to see if you need any more darks but don't fiddle. Keep things simple, especially the water.

COLOUR MIXING

If you have enjoyed painting ducks, you really have a treat in store, since chickens are an equally exciting subject to observe and paint. When you start going out to paint chickens from life, try to spend plenty of time observing all their different and wonderful hues. The colours of cockerels can be absolutely glorious and both cockerels and chickens have a natural shine to their feathers which, when the sun catches it, makes them appear lighter. If you look carefully at chickens, you can see reflected colour, as with my white ducks on pages 48 and 50. You will also notice that a chicken's beak is often the same colour as its legs.

In this section, I show you the colour mixes I use for painting chickens and I hope you will have great fun practising them. These are my usual colours but, naturally, mixed in different orders and amounts can make many different colours.

1 *Red, yellow and blue, the three primaries, are the magic colours – remember you can mix almost any colour from these. In fact, this black chicken is a very dark shadow colour mixed from these three colours.*

2 *The colour for the cockerel's comb is mixed from Cadmium Red and Crimson Alizarin.*

3 *This dark brown mix of Crimson Alizarin, Yellow Ochre and French Ultramarine can be used on many types of chicken.*

4 *The legs and feet are Yellow Ochre mixed with Crimson Alizarin. This is just one of many different leg colours that you will find on chickens' legs.*

5 *For tail feathers, French Ultramarine and Crimson Alizarin mixed together make various shades of warm blue, while Hooker's Green No. 1 and French Ultramarine make different bluey-greens or greeny-blues.*

6 *For this golden cockerel, paint Yellow Ochre and Cadmium Yellow into a shadow mix.*

7 *Some chickens have dark heads going into golden-brown bodies. For this colour, mix Crimson Alizarin with Yellow Ochre and drop in more Yellow Ochre while the paint is wet.*

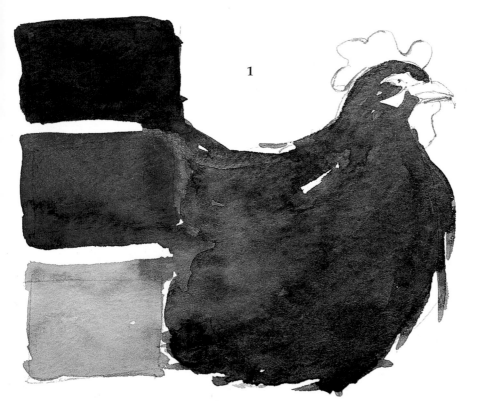

1

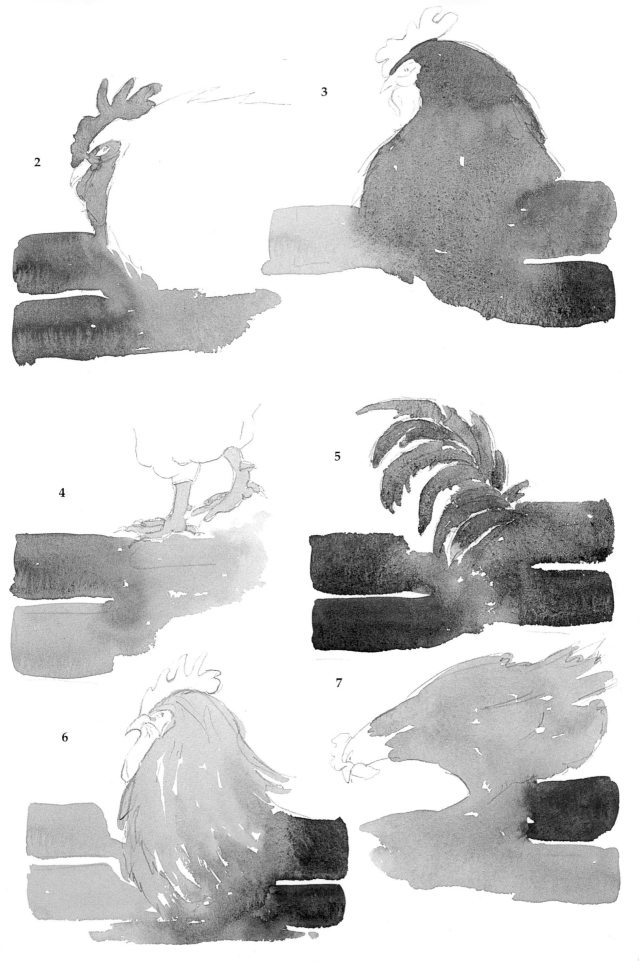

2

3

4

5

6

7

◆ *Ducks & Chickens* ◆
PENCIL SKETCHING

Sketching chickens is very similar to sketching ducks but they are probably even more comical. Their heads are never still and, when chickens walk, they stretch their necks back and forth at quite a rate. You'll probably spend quite a bit of time laughing as you try to sketch them – I do! When the novelty wears off a little, you can get down to some serious work.

Do plenty of simple pencil sketches like the ones below to start with, just trying to get the shape and movement of chickens, as you did with the ducks. When they scratch and peck at the ground, chickens sometimes stop midway as though they are frozen in time. That's when you have a few extra seconds to sketch them, so be prepared to grab that moment when it comes!

▼ Cartridge paper
19 × 14 cm (7½ × 5½ in)
I just had time for a quick line drawing before he turned away!

Cartridge paper
22 × 29 cm (8½ × 11½ in)
Keep your pencil moving and get some sketches down on paper before your chickens escape!

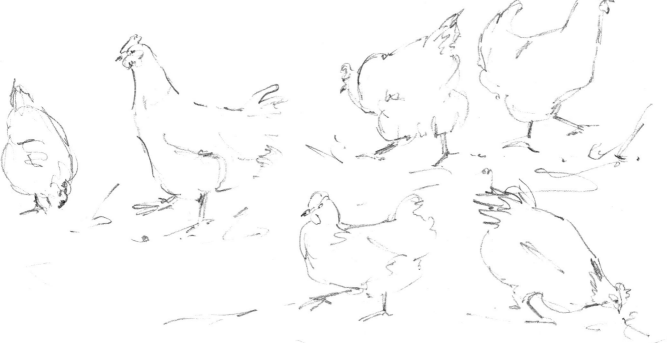

▶ Cartridge paper
17 × 17 cm (7 × 7 in)
I shaded this rather angry-looking cockerel quite heavily to give him a look of importance. I was very glad that I was on the other side of the fence!

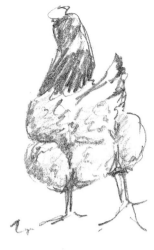

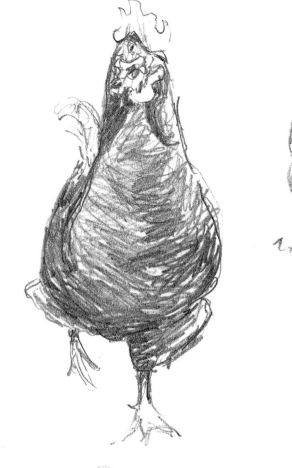

▼ Cartridge paper
22 × 28 cm (8½ × 11½ in)
These chickens were rushing around being busy. Remember as you did with the ducks, use pencil shading to give strength and form to your drawing.

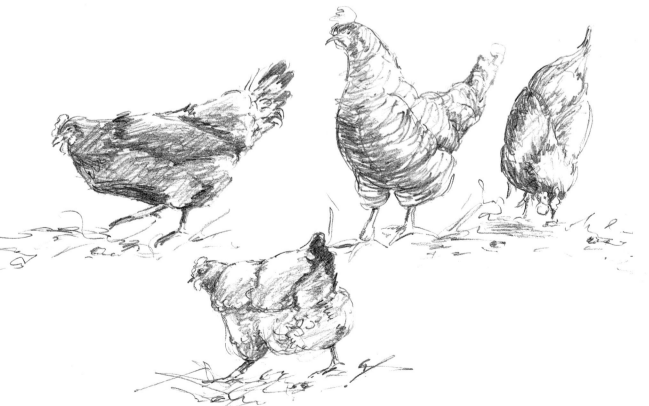

◆ *Ducks & Chickens* ◆
PAINTING WITHOUT DRAWING

Looking at chickens done in this way without drawing, you might almost be tempted to put more tonal work on them and call then finished paintings. But that would defeat the object of this exercise, which is to be completely free with your brush and paint. So don't be tempted to overwork them. For now, just have fun! Look at the lovely colours in the cockerel, below, and start painting. And don't forget you can also use photographs for inspiration to copy from, as well as your pencil sketches.

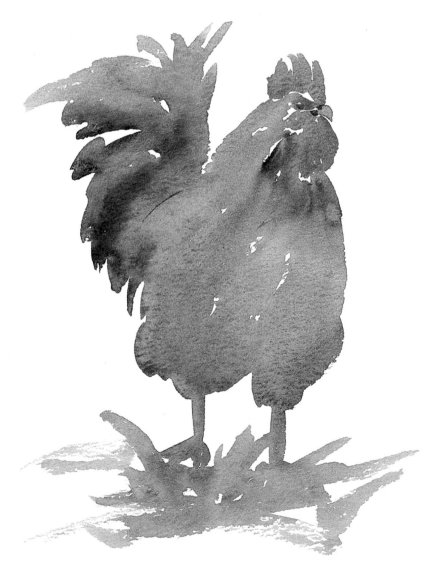

◀ Bockingford 140 lb
22 × 17 cm (8½ × 7 in)
Just look at this proud cockerel! First paint the comb. Let the dark colour under his neck run into the golden brown of the body. Paint the green and blue tail feathers while the body is still wet, and then the feet and grass.

▶ Bockingford 140 lb
45 × 35 cm (18 × 14 in)
This exercise shows how simply chickens can be suggested in watercolour. If it wasn't for the suggestion of red combs, beak and legs, the three chickens painted from the rear could just be blobs of paint. Notice how I have let the paint run together while it is still wet when painting the cockerel on the right. Paint freely but leave unpainted areas of white paper to show shape and form, like the very thin white line separating parts of the head from the body. There are also unpainted areas in the body. Brush strokes should go in the direction that the feathers grow and these white areas are left naturally when you are painting.

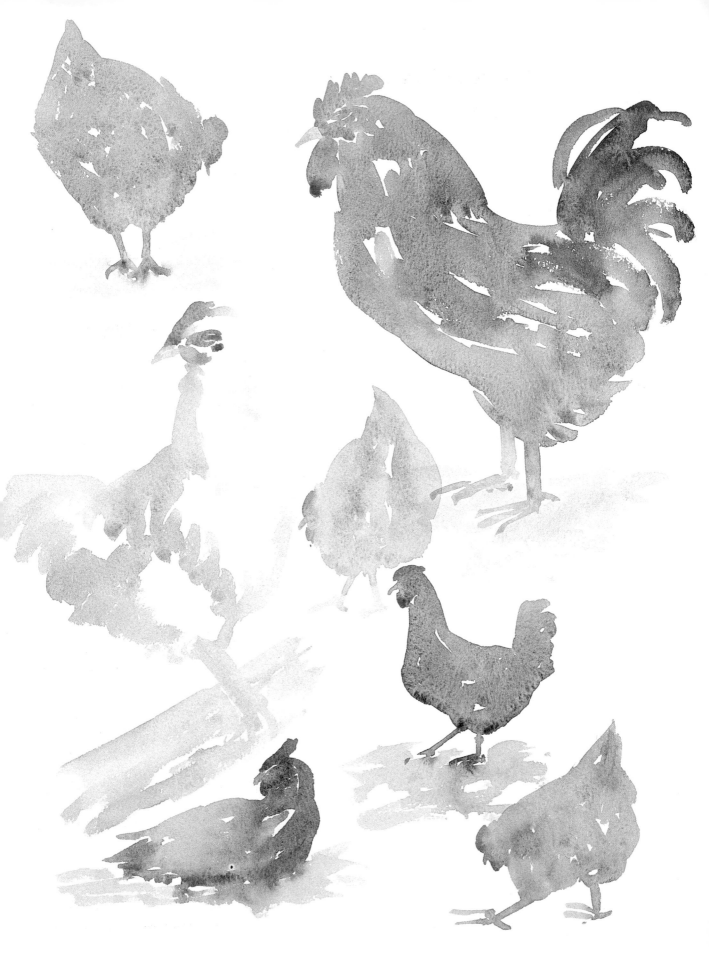

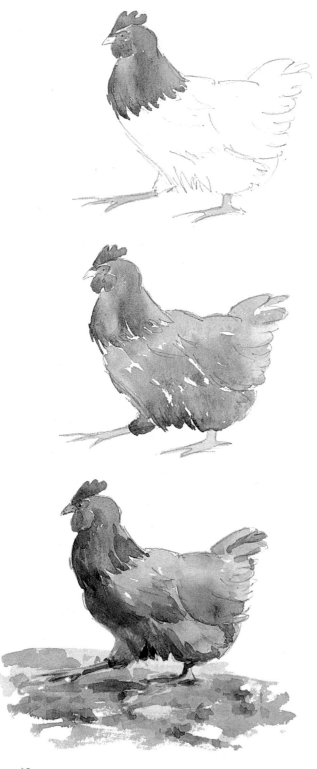

CHICKEN

◄ STAGE 1
Draw the chicken with pencil, then paint the comb with a mix of Cadmium Red and Crimson Alizarin. When this is dry, paint the head and neck with a mix of Crimson Alizarin, Yellow Ochre and French Ultramarine. Paint the feet Yellow Ochre and a touch of Crimson Alizarin.

◄ STAGE 2
Mix Yellow Ochre with a touch of Crimson Alizarin and plenty of water and paint under the neck feathers, along the back, and the tail feathers. Add more Crimson Alizarin for the rest of the body, adding French Ultramarine for the darker areas.

FINISHED STAGE
Paint in the ground with a mix of Crimson Alizarin, Yellow Ochre and a touch of French Ultramarine. Mix French Ultramarine, Crimson Alizarin and a touch of Yellow Ochre to darken the comb, paint the beak and work down the neck feathers. Strengthen this colour to paint the other dark areas, under the chest and tail, on the legs and under the body.

◄ FINISHED STAGE
Bockingford 200 lb
43 × 22 cm (17 × 8½ in)

COCKEREL

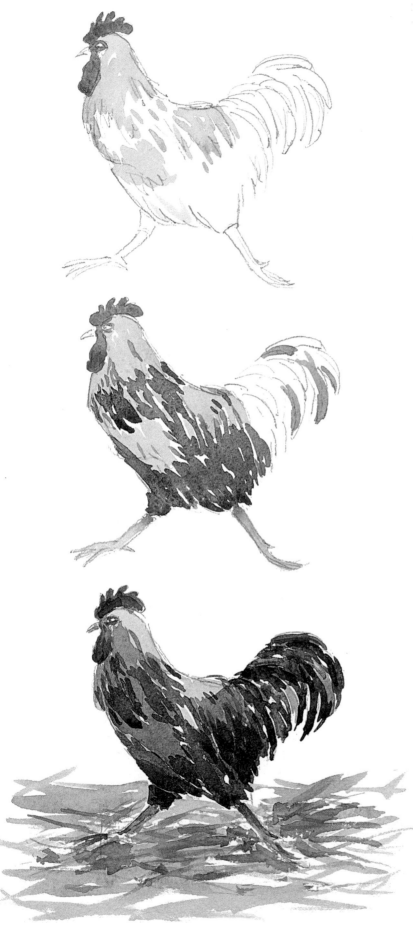

◄ STAGE 1

Draw the cockerel with pencil and then paint the comb using Cadmium Red mixed with a little Crimson Alizarin. When this is dry, start at the top of the head and paint the yellow feathers using a fairly watery mix of Cadmium Yellow Pale and Yellow Ochre. Paint freely in the direction of the feathers, leaving areas of unpainted paper as you work.

◄ STAGE 2

Mix French Ultramarine, Crimson Alizarin and a touch of Yellow Ochre and paint the dark feathers, varying the colour as you work. Use Hooker's Green No. 1 to paint the tail feathers.

FINISHED STAGE

Using the dark feather colour, paint in the rest of the tail feathers, putting extra colour in to darken some of them. Now mix Yellow Ochre with a touch of Crimson Alizarin and paint the straw. Using the dark feather colour and adding water to make it paler, paint shadows on the whole of the cockerel. Leave the top of the head, the back and some of the tail feathers as unpainted paper. It adds to the sparkle if you leave little areas of brightness in places. Finally paint shadows on the straw.

◄ FINISHED STAGE
Bockingford 200 lb
43 × 22 cm (17 × 8½ in)

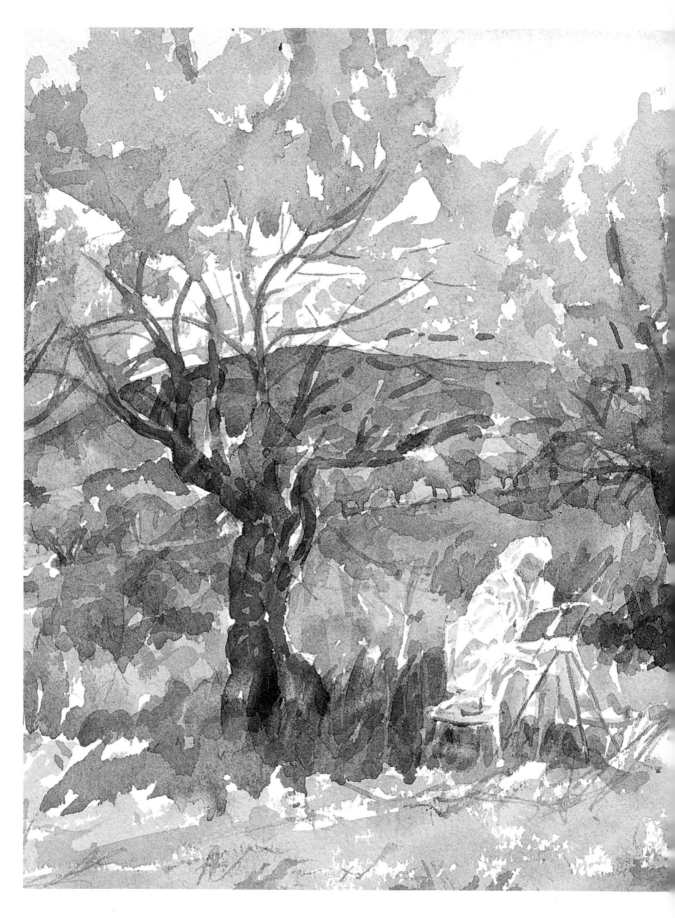

◆ *Simple Landscapes* ◆

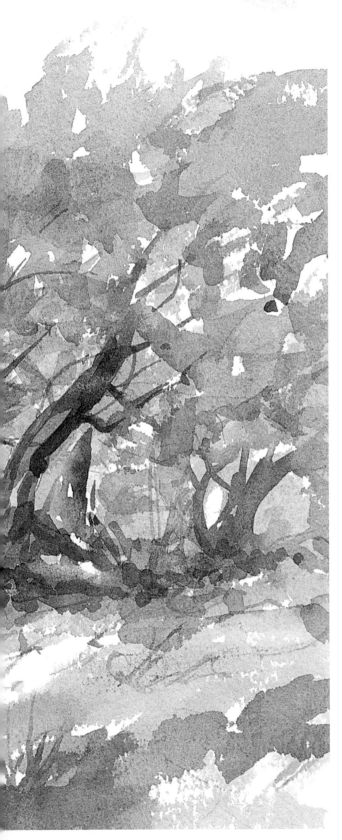

When you are painting outside there is always plenty to inspire you and landscape is a very popular subject for most painters and especially watercolourists. You may choose to paint soft gentle scenes or ones bustling with people, animals or vehicles. However, it isn't essential that your location is one of great beauty or drama – even everyday scenes can make interesting and colourful paintings.

For this reason, I take my paints wherever I go in case I get an opportunity to paint a landscape. Sometimes there is only time for a quick fifteen minute sketch but even these can turn out to be little gems!

◆ *Simple Landscapes* ◆
COLOUR MIXING

I couldn't begin to mix all the colours that you see in the landscape but I can show you how to mix general colours that you will find in the countryside. You will naturally learn more about mixing colours by painting from nature than from your photographs, but remember that it isn't necessary to paint the exact colours that you see. A watercolour painting should simply be an impression of the scene.

The colours you use for painting landscape will obviously depend upon the weather. A sunny day will demand bright colours, while a misty or rainy one will need paler mixes. Always keep your eyes open to the beautiful colours of the countryside. Tree trunks come in lots of different colours but you can paint many variations from the two colour mixes I have shown for them on the opposite page. The same applies to the greens in nature. Use the same green mixes that you practised for the flowers on page 25. Variations of these greens will give you all the colours you will need for foliage.

1 *A simple sky can be created with a wash of French Ultramarine and a touch of Crimson Alizarin, adding more water and Yellow Ochre as you work down the page.*

2 *At certain times of the year, tree trunks can be very green. You can create lots of different greens with various mixes of Hooker's Green No. 1 and Crimson Alizarin.*

3 *This is just one type of grass you can get by mixing French Ultramarine with Cadmium Yellow Pale and plenty of water.*

4 *French Ultramarine, Crimson Alizarin and a touch of Yellow Ochre make the stormy clouds. This shadow mix must be very familiar to you by now since I use it all the time. Yellow Ochre with water is the bright sky beneath.*

5 *Certain trees have lovely silvery trunks and, again, my shadow mix, with plenty of water, makes this lovely colour. The autumn leaf colour is Cadmium Red and Yellow Ochre.*

6 *This ground is very pebbly. You could leave out the Cadmium Red but I love the rich warm glow it gives. Mix Cadmium Red and Yellow Ochre with lots of water for the orangey pebbles. Paint some of them with just Yellow Ochre and use the three primaries to paint the dark pebbles and shadows.*

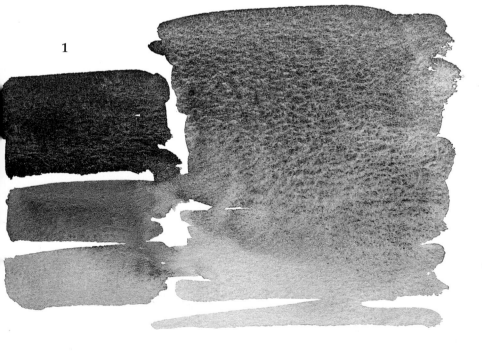

1

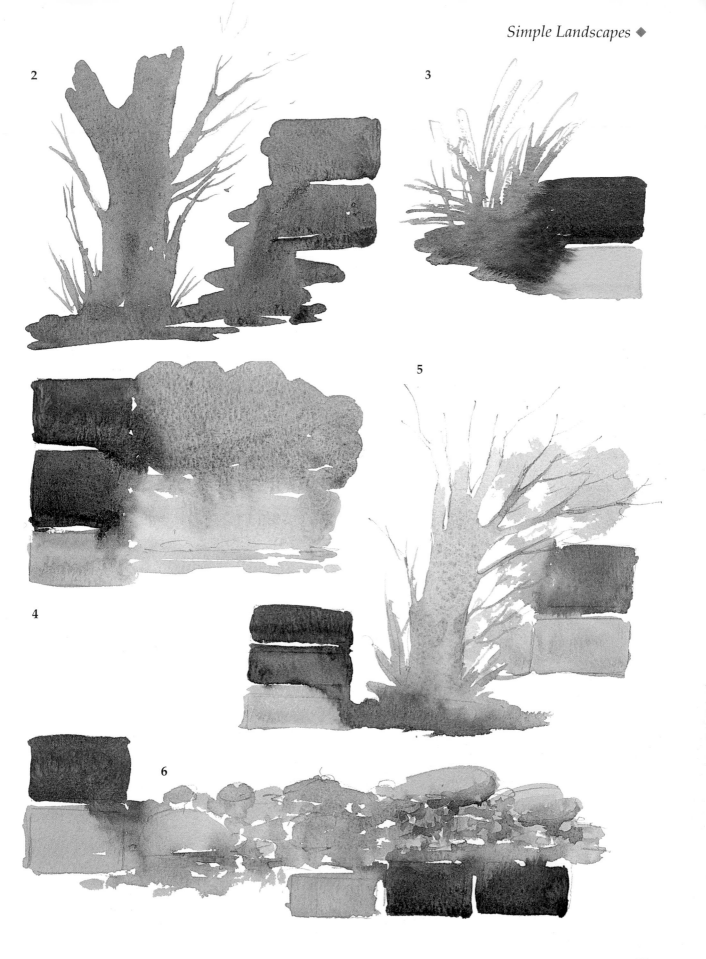

2

3

4

5

6

◆ *Simple Landscapes* ◆
PENCIL SKETCHING

Sketching landscape can be a relaxing pastime or all hustle and bustle, depending on where you are working! Since it can be offputting to be surrounded by people when you are a beginner, I suggest you find a quiet field to start with, rather than a popular beauty spot. If it's a sunny day and the weather is settled, you can take your time and enjoy your subject but, if the weather is changeable, you may have to work quickly to avoid the rain. Of course, speed is also necessary when there are moving objects like boats, animals or clouds in your picture.

Before you start to sketch, study the scene and decide on the area that interests you most. This centre of interest should be the most important part of your sketch. I find it normally works to draw in this area first and then continue with the rest of the landscape. Depending on your subject, you might find it easier to start your drawing from a different point and there are no set rules for this.

Cartridge paper,
reproduced actual size
The centre of interest in this simple pencil sketch is the bright sky between the trees. Remember to put colour notes on the back of all your sketches and make a note of where the sun is. This information will help you when you use them to paint from at a later date.

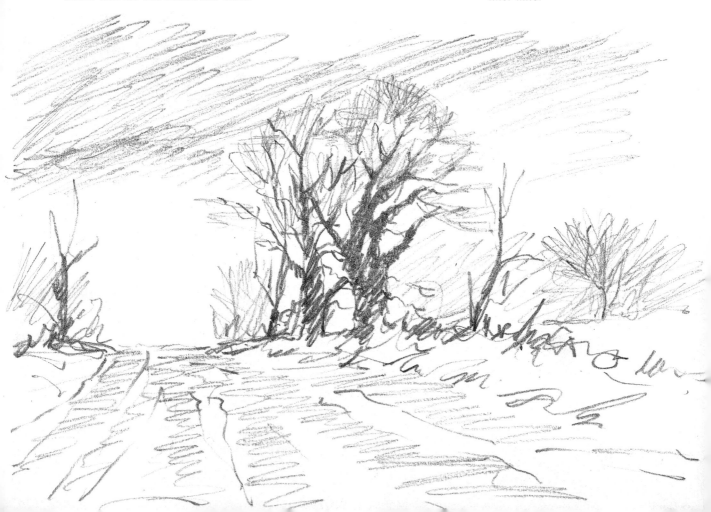

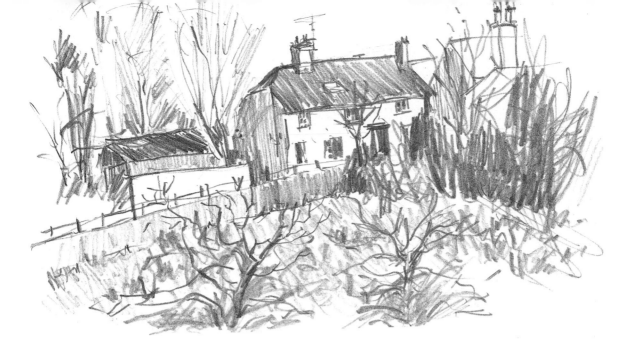

▲ Cartridge paper
12 × 17 cm (5 × 7 in)
Although this sketch has a lot of work in it, it is still quite freely done. A building needs fairly uniform shading but grass and trees can be much more scribbly.

▶ **Close-up detail**
This detail from my pencil sketch, above, is reproduced 50 per cent larger than actual size. See how the roof is much more carefully shaded than the grass and trees.

▼ Cartridge paper, reproduced actual size
I had no time to fiddle when I did this quick little sketch from a moving boat. The windmill was the most important object (centre of interest) so I shaded it in to make it prominent. A sketch like this can be a lovely souvenir.

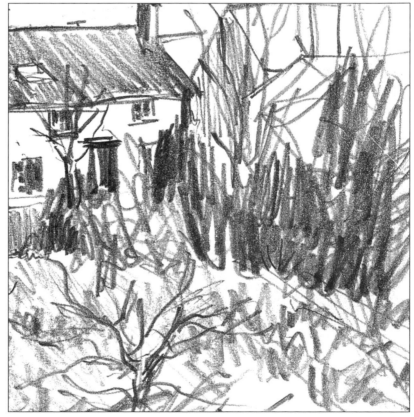

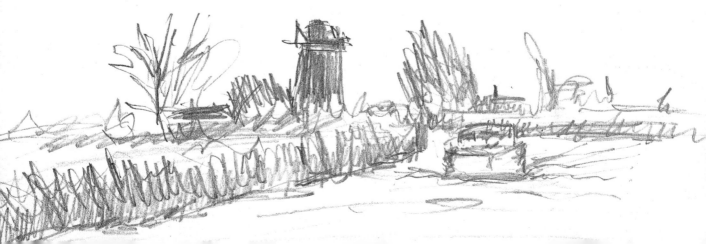

PAINTING WITHOUT DRAWING

Some artists like to paint a whole landscape without sketching it first. However, most prefer to put in some pencil guide lines, even if their subject is a fairly simple one. Of course, if the scene is complicated, the drawing for it can be quite detailed. However, I know that practising painting landscape without drawing will bring a freedom to your work and will help stop it becoming fiddly. I always prefer to paint the sky without drawing it because I feel that the results I get look far more natural this way.

Tinted Bockingford 140 lb
28 × 38 cm (11 × 15 in)
This sunset was literally changing by the second and so it had to be worked extremely quickly.
I painted the yellow-orange sky first and then allowed this to dry before I painted the clouds, trees and land.

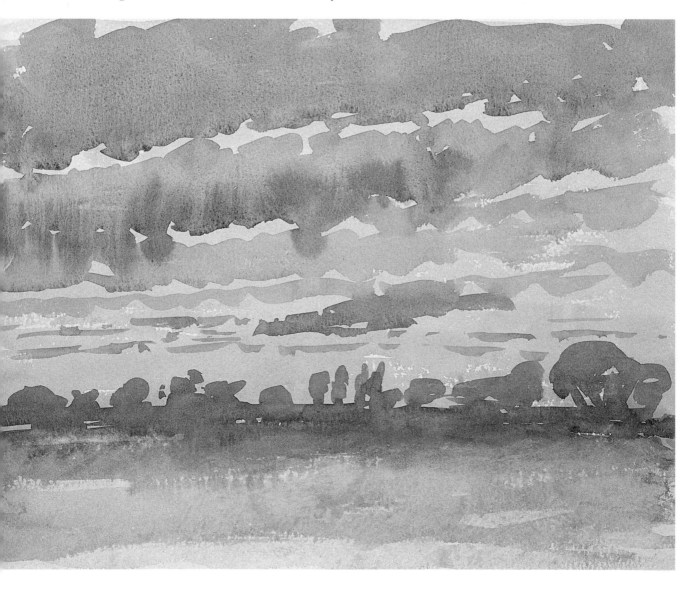

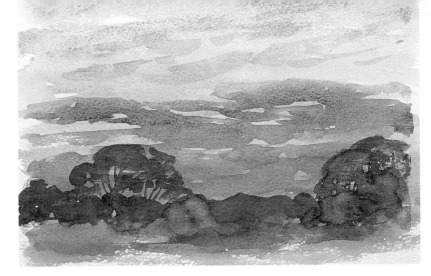

▶ Bockingford 140 lb
17 × 25 cm (7 × 10 in)
This painting was done minutes after the one on the previous page. Notice how the colours and cloud shapes have changed! Once the first two sky washes had dried, I painted in the trees and land.

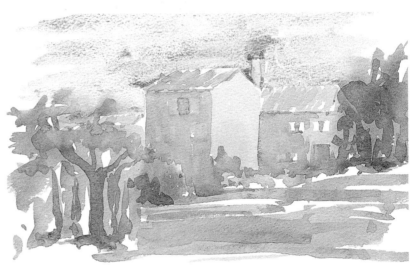

▶ Bockingford 140 lb
17 × 25 cm (7 × 10 in)
Don't attempt to do anything too complicated as you will find it too difficult without drawing first. These buildings in Italy were very simple.

◀ Cartridge paper
24 × 20 cm (9½ × 8 in)
Practise painting trees – and don't worry! Just enjoy your painting and use your sketches and photographs to copy.

◆ *Simple Landscapes* ◆
WATERCOLOUR SKETCHING

When you go out sketching in watercolour, choose a fairly simple subject to start with but make sure that it excites you. It could be the way sunlight is dancing on water or just the interesting shape of a tree.

Whatever it is, if it inspires you, paint it. But first look carefully at the scene to make sure it will make a painting. A field of golden corn may look fine in a real-life landscape but can create a big yellow void in a painting and, if it is in the wrong place, make it look weak and uninteresting. A tree placed in the wrong position on a sketch can dominate it, although not intended to be the centre of interest.

When I draw a sketch, if it looks 'happy' on the paper, then I will go on to paint it. However, if it doesn't sit happily on the paper, I readjust it or start again.

Cartridge paper
12 × 20 cm (5 × 8 in)
I did this little painting as a half-hour exercise at a coach stop in Provence. The shape of the mountain was very important. There was only time to paint the main darks and lights of the landscape – I left the houses as white paper. Notice how the paint runs back in the sky. This often happens when you paint quickly outside on cartridge paper and is quite acceptable.

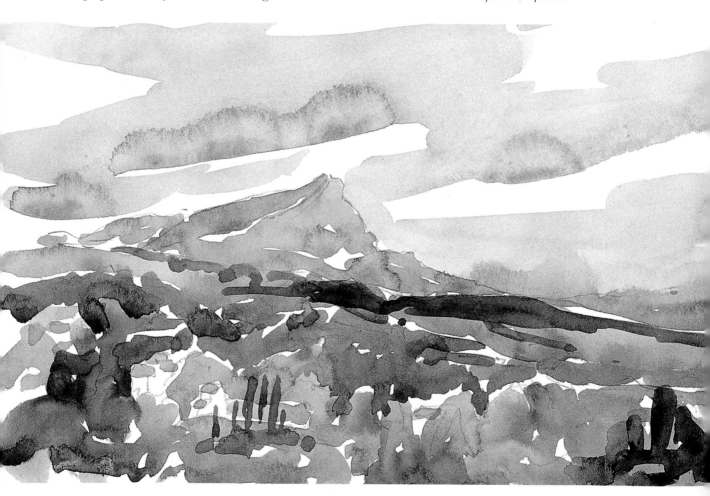

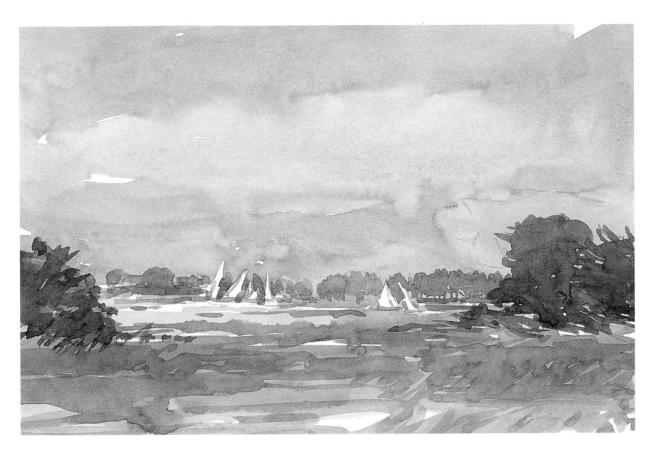

▲ Cartridge paper
22 × 29 cm (8½ × 11½ in)
I painted a dark wash for the sky, leaving white paper for the yacht sails. I left some sky between the tree trunks when I painted the distant trees (see the detail below). The bright light on the fields and the warm dark green of the foreground trees and grass gives just the right stormy mood to the sketch.

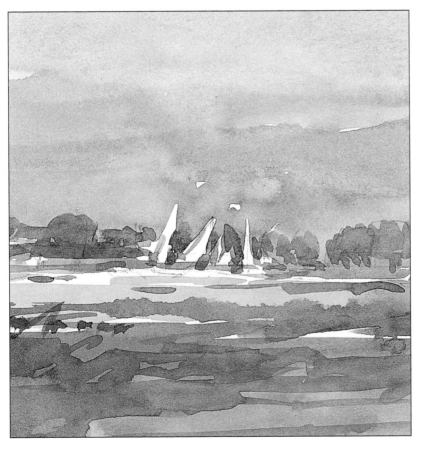

◄ CLOSE-UP DETAIL
This detail is reproduced actual size. The bluey-green colour of the distant trees makes them recede, while the warmer green of the nearer trees makes them come forward. Leaving white paper for the yacht sails suggests strong sunlight and keeps the painting looking fresh.

◆ *Simple Landscapes* ◆
WORKING FROM A PHOTOGRAPH

When working from a photograph, your most important decision is what to leave out. The car in this photograph does add a splash of stronger colour but I left it out because I wanted the buildings to be my centre of interest. I liked the tree and moved it a little nearer to the house to make a better composition. Be slightly wary when copying photographs because they can tend to flatten a scene. That's why it's important to do a pencil sketch as well, if possible.

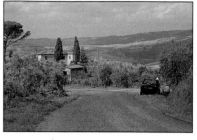

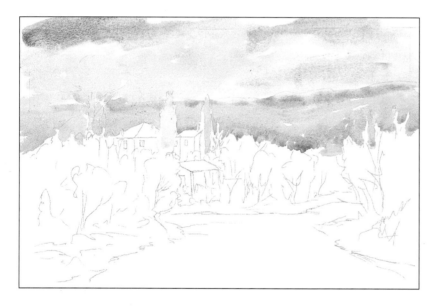

◀ STAGE 1
Draw in the scene with pencil and then make four separate puddles of paint with Coeruleum Blue, French Ultramarine, Yellow Ochre, and, finally, French Ultramarine with a little Crimson Alizarin.

Use your No. 10 brush to paint a very free wash from left to right, starting with Coeruleum Blue, then French Ultramarine and going down into Yellow Ochre clouds. Leave a little white paper here and there, then add French Ultramarine and Crimson Alizarin into the hills. Run the sky colour into the cypress trees and the tall left-hand tree. Carry on into the land with Yellow Ochre, then paint a bluey-green going into stronger blue shadow colour on the right, but stopping at the roof tops and olive trees.

◀ STAGE 2
Using your No. 6 brush, paint the roofs Cadmium Red and Yellow Ochre, then paint the houses Yellow Ochre. Paint the

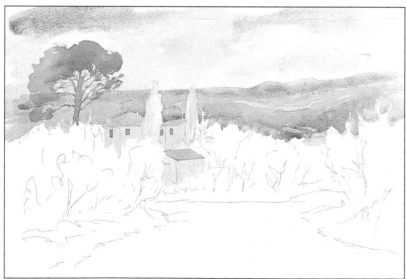

garage with a pale mix of French Ultramarine and Crimson Alizarin. When the roofs are dry, paint over the hills with a wash starting with French Ultramarine but making it paler in the middle and then stronger, with a touch of Crimson Alizarin, above the olive trees and the right foreground tree. Leave areas unpainted to suggest sun on the fields.

Paint the shutters a bluey-green and then paint the trunk on the tall left-hand tree, using your Rigger brush for the smaller branches. The foliage is made up of a mixture of different greens.

STAGE 3

Paint the cypress trees using your No. 6 brush and a mix of Yellow Ochre and Cadmium Red, running into Hooker's Green No. 1, Crimson Alizarin and a little French Ultramarine. Then paint the olive trees in the middle section to the right of the houses, starting with almost pure water running into a mix of Hooker's Green No. 1 and French Ultramarine. Add a little Crimson Alizarin and use your Rigger for the trunks.

Paint the left-hand foreground trees using your No. 10 brush and various mixes of green – paint the overall tree shapes and put in the branches while the paint is still wet. Paint the grass verges with the same freedom and then paint the road Yellow Ochre but dirty it up a little.

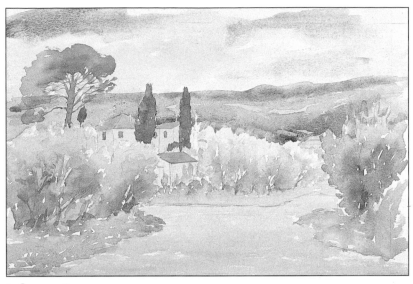

▲ **STAGE 3**

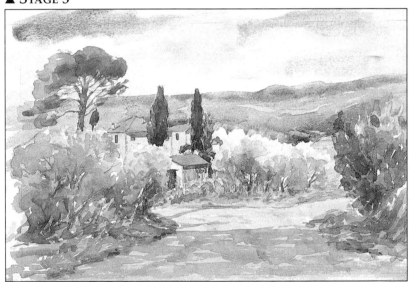

▲ **FINISHED STAGE**
Bockingford 200 lb
38 × 56 cm (15 × 22 in)
Paint the shadows on the buildings and cypress trees with your No. 6 brush and the usual mix of French Ultramarine, Crimson Alizarin and a touch of Yellow Ochre.

Work shadows under the foliage of the tall left-hand tree and on the trunk, then put softer shadows on the olive trees. Change to your No. 10 brush to paint shadows and darker greens on the left-hand foreground trees, and then add trunks and branches where needed with your No. 6 and Rigger brushes.

Paint shadows and extra greens on the verges and make the right foreground trees darker – this helps to push the olive trees back. Finally, paint the shadows on the road.

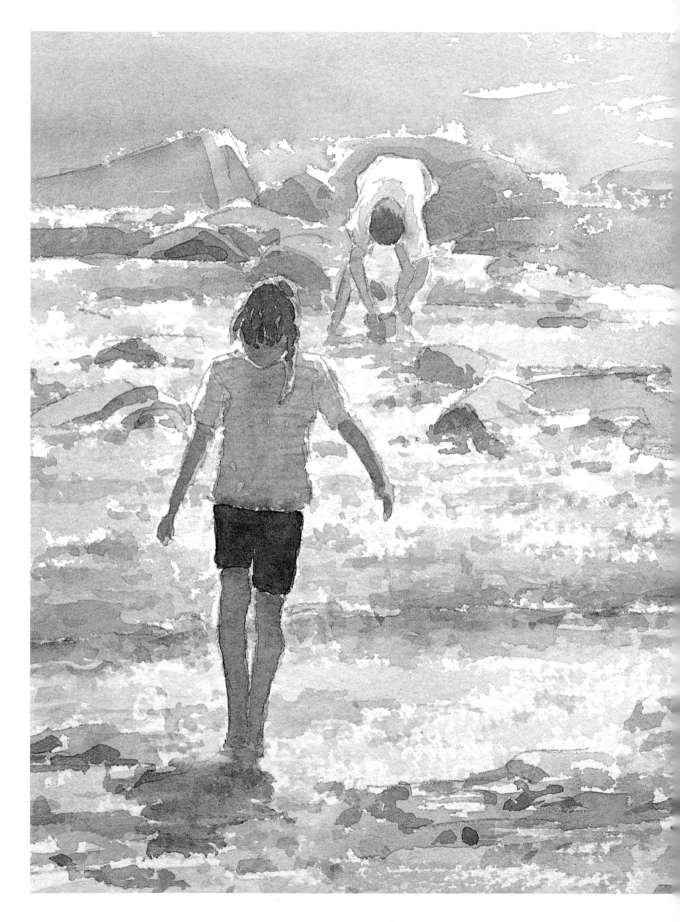

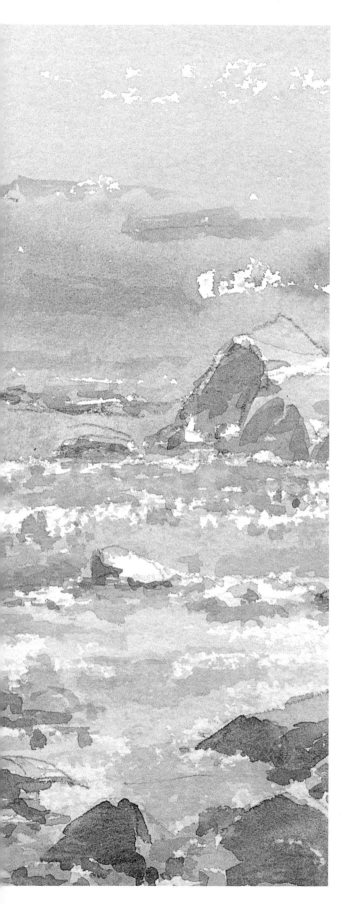

◆ *Beach Scenes* ◆

*P*ainting beach scenes is a wonderful way to remember where you have been and what you have seen. My local beach at Dawlish in Devon is full of holidaymakers during the summer and it is one of my favourite places to work. Of course, you have to pluck up the courage to sit among so many people and paint but don't worry – they are usually far too busy enjoying themselves to notice you!

COLOUR MIXING

The usual principles of colour mixing apply to beach scenes with people, although you will find you use a lot of pure colour (single colours mixed with water) for bright beach clothes and other holiday paraphernalia. I have given you two flesh colour mixes but obviously skin comes in many different shades.

Remember that the colours I show you here can make many different shades if you add more of one colour or less of another, or if you vary the amount of water used. As you progress, you can add more colours to the same mix – if you mix red and yellow to make a flesh shade, adding a little blue will darken or subdue the colour. By now, I am sure you realise how important colour mixing is, so do try to get as much practice as you can.

1

1 *Vary the colour of the blonde girl's hair with Cadmium Yellow Pale and then Yellow Ochre. The dark hair is mixed from the three primaries and the shadow on the blonde girl is the same mix with more water added. The dark girl's flesh is Crimson Alizarin with Yellow Ochre and lots of water.*

2 *Beach umbrellas come in many different colours. Mix French Ultramarine with a little Crimson Alizarin to make this bluish-purple.*

3 *Make this flesh colour by mixing Cadmium Red with Yellow Ochre and plenty of water.*

4 *The sea varies tremendously in colour according to weather and location. For this sea colour, use Coeruleum Blue and Hooker's Green No. 1 with plenty of water.*

5 *My local beach in Devon has reddish-coloured sand. For this, mix Yellow Ochre and Cadmium Red with plenty of water.*

6 *This bucket is Crimson Alizarin with plenty of water. Add a little French Ultramarine for the inside.*

7 *Windbreaks, like beach umbrellas, come in a variety of colours. To paint this one, use French Ultramarine with a touch of Crimson Alizarin and plenty of water for the main colour. The stripes are pure Cadmium Yellow Pale and pure Cadmium Red.*

2

3

4

5

6

7

◆ *Beach Scenes* ◆
PENCIL SKETCHING

When you sketch people, they can pose the same problem as ducks and chickens – they just won't keep still! If you pick someone in a deck chair who appears to be sleeping, you can guarantee that, as soon as you start to draw them, they will get up and go for a swim. Even if they stay put, their arms and legs never remain in the same position for very long. Never mind, you should be able to cope with movement by now and don't forget that even people can be drawn from more than one model!

If you are on the beach with your friends or family, why not persuade them to pose for you? When you're sketching, don't worry about objects around people, like bags or towels, because these will usually stay in one place. Sketch people first – they will move!

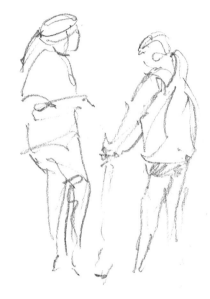

▲ Cartridge paper
12 × 10 cm (5 × 4 in)
I had just started sketching here. People were moving about a lot and my pencil hadn't really got going properly.

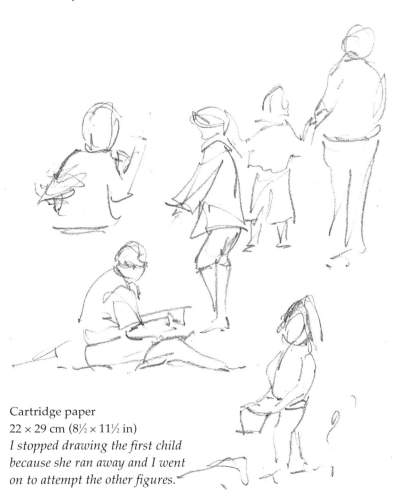

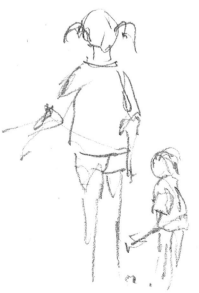

Cartridge paper
22 × 29 cm (8½ × 11½ in)
I stopped drawing the first child because she ran away and I went on to attempt the other figures.

78

▶ Cartridge paper
20 × 20 cm (8 × 8 in)
This sketch was more ambitious,
as my pencil was beginning to
really move by now. Unfortunately,
the two middle figures got up to
get ice creams and I had to leave
the sketch unfinished.

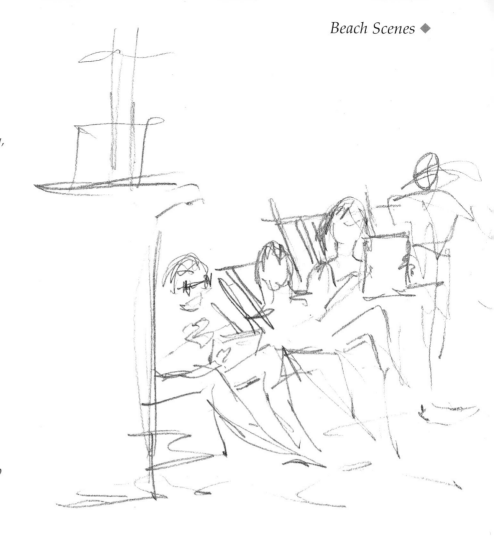

▼ Cartridge paper
11 × 22 cm (4½ × 8½ in)
I picked out individual children to
sketch from the groups playing
down by the sea. By now, my
pencil was getting more used to
drawing and I was adding tone
with my pencil, which gives the
figures more shape.

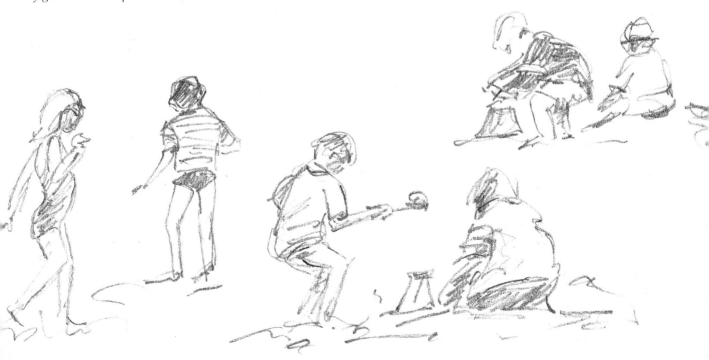

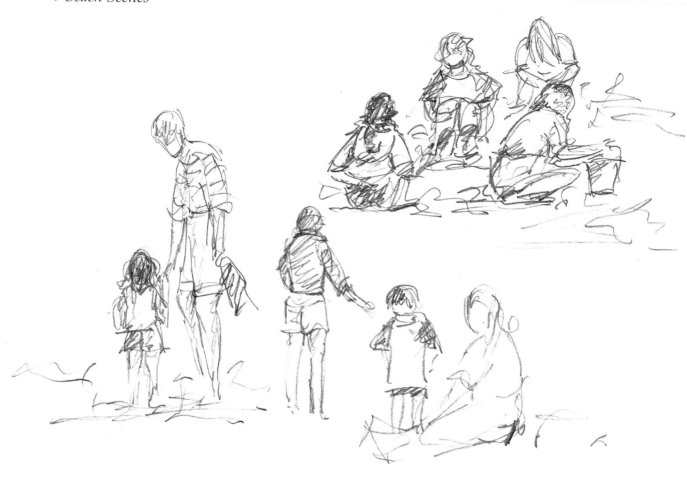

▲ Cartridge paper
22 × 29 cm (8½ × 11½ in)
These sketches of figures are much more relaxed. My pencil was really moving about and almost scribbling. Don't worry if you don't finish some of your sketches, just relax and enjoy doing them.

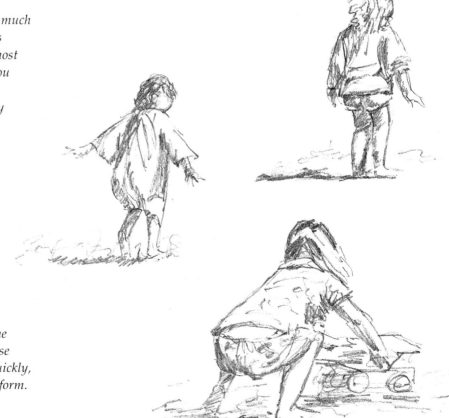

▶ Cartridge paper
23 × 20 cm (9 × 8 in)
The more sketches you do, the faster you get! Although these children were drawn very quickly, I still added shading to give form.

◆ *Beach Scenes* ◆
PAINTING WITHOUT DRAWING

The more you get used to the human shape, the easier it is to paint and sketch groups of people. When you are copying people from life, your drawing will often be very scribbly because you are working quickly. When you come to paint them, your brush will have to reconstruct some of them. Therefore it is very important that you are confident painting people just with your brush. Spend time observing the different attitudes and actions of people. It is sometimes helpful to use videos or photographs to practise from.

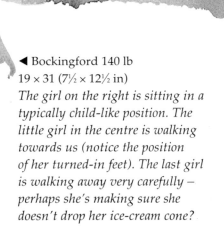

▶ Bockingford 140 lb (*top*)
30 × 19 (12 × 7½ in)
The way this girl is standing suggests that she is pulling up her jeans.

◀ Bockingford 140 lb
19 × 31 (7½ × 12½ in)
The girl on the right is sitting in a typically child-like position. The little girl in the centre is walking towards us (notice the position of her turned-in feet). The last girl is walking away very carefully – perhaps she's making sure she doesn't drop her ice-cream cone?

◆ Beach Scenes ◆
WATERCOLOUR SKETCHING

Now it's time to go out and paint on the beach from life as soon as you can. If you don't live near a beach, make it the project for your next holiday. Don't worry if the beach is crowded. Find a spot near to some likely subjects – it's helpful to select a small group of holidaymakers but don't choose ones who are obviously about to pack their bags and leave the beach! Don't be dismayed if your first painting efforts aren't brilliant, and don't feel you have to paint complete pictures first time.

▲ Cartridge paper
22 × 29 cm (8½ × 11½ in)
My centre of interest was the two foreground figures. The very simple wash of colour on the sea and sand, with the added interest of the windbreaks and deck chairs in the distance, makes a simple but attractive beach painting.

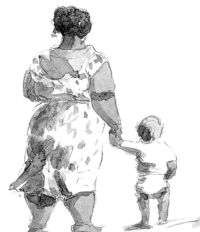

◀ Cartridge paper
9 × 7 cm (3½ × 3 in)
This mother and child by the sea enchanted me and I did many sketches of them as they played in the water. Notice how the strong shadows suggest sunlight.

▶ Cartridge paper
11 × 15 cm (4½ × 6 in)
I was inspired by these children making sand castles and I did a quick pencil sketch first, adding shading. Having decided there was time to paint the sketch, I did this with simple washes, putting shadow colours on after it was dry. I was very pleased with the result.

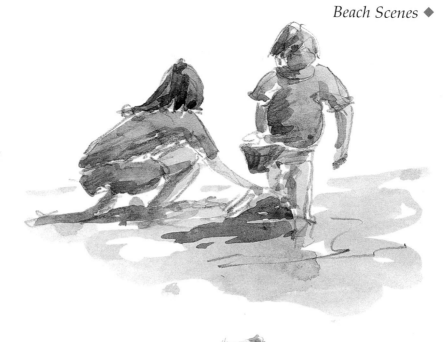

▶ Cartridge paper
11 × 17 cm (4½ × 7 in)
I took a little more time with this one because drawing deck chairs can be a little tricky. The person's shape showing through the material is very important and helps to give the impression of sunlight. I didn't bother with any background because the deck chairs were what interested me.

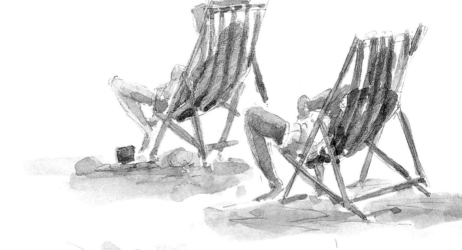

▶ Bockingford 72 lb
12 × 17 cm (5 × 7 in)
This was a very quick sketch because I was afraid they would move. I loved the dark umbrella, hat and shorts and, in particular, the man's tummy! I was so absorbed painting quickly, that I didn't notice until I had finished that the couple look as if they are on a hill. They were tipping slightly but not as much as I painted them. Never mind! I enjoyed it and captured the essence of the scene. Notice how the strong shadows help to suggest sunlight.

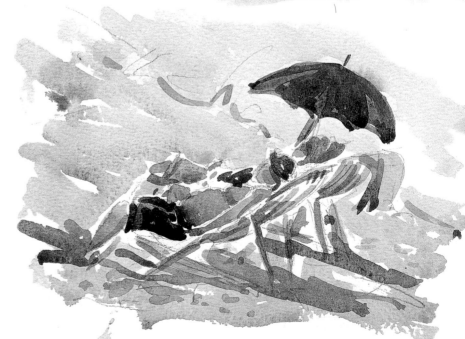

◆ *Beach Scenes* ◆

DEMONSTRATION 1

This demonstration takes you through a painting I did on my local beach. Each stage was photographed as I painted it. That in itself was pretty scary! I had to work very quickly and, as well as observing the children, had to keep one eye on the weather because rain clouds were building up. My subjects were reasonably settled building sand castles but one little girl kept running down to the sea to fill her bucket. Luckily, she always came back, so I could still paint her. In fact, they all ran away just as I finished the painting and the rain clouds disappeared, too!

◀ STAGE 1
On the beach, it is always a great deal easier to work in your cartridge sketchbook than on single sheets of paper. Start by drawing the scene in with pencil.

◀ STAGE 2
Use Cadmium Red and Yellow Ochre for flesh tones, watery Crimson Alizarin for the striped top and a mix of Coeruleum Blue and Hooker's Green No. 1 for the green sleeves. Paint the bucket, shorts and trousers with Cadmium Yellow Pale and a touch of Hooker's Green No. 1. For the hair and cap use French Ultramarine, Crimson Alizarin and a touch of Yellow Ochre.

▶ STAGE 3

Paint a wash for the sky using Coeruleum Blue, then add French Ultramarine with a touch of Crimson Alizarin. Paint the beach with Yellow Ochre and a touch of Cadmium Red.

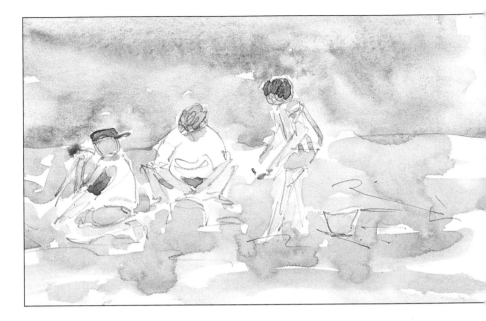

▶ FINISHED STAGE

Cartridge sketchbook
15 × 24 cm (6 × 9½ in)
Paint in the shadows on the figures and beach with the usual mix of French Ultramarine, Crimson Alizarin and a touch of Yellow Ochre.

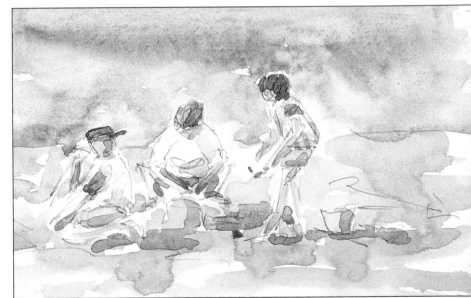

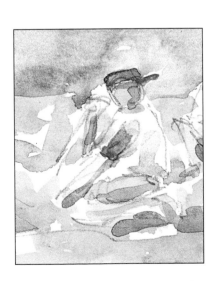

CLOSE-UP DETAILS

◀ *Don't try to paint faces in when doing figures this size. A simple impression is all you want to achieve.*

▶ *Notice how freely this painting was done. There isn't time for any fiddling when you are painting at speed. The shadow helps to show form.*

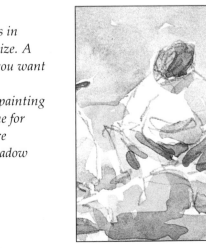

◆ *Beach Scenes* ◆
DEMONSTRATION 2

My last watercolour painting worked out very nicely but I did a second demonstration that day, just in case! When I returned to my studio, I decided to include both of them in the book. This second sketch is more controlled than the first, probably because I had already had some practice that day. If your subjects leave before you can finish painting them, don't worry. You can cheat a little and you should be able to remember the colour of their clothes and other details, so try to paint them from memory. The beach and surroundings can also be worked on if the figures have gone.

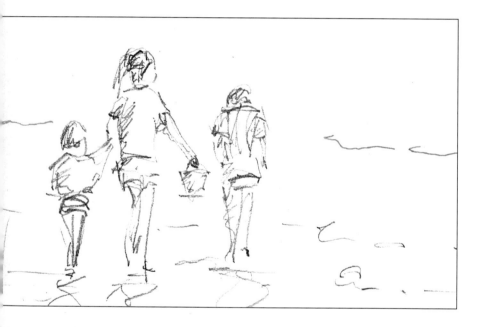

◀ STAGE 1
I drew this scene in pencil on the next page in my cartridge paper sketchbook.

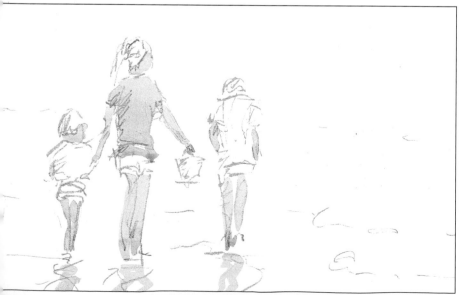

◀ STAGE 2
Start by painting the green top using Hooker's Green No. 1 and Cadmium Yellow Pale. Mix Cadmium Red and Yellow Ochre with plenty of water for the flesh colour and reflections.

▶ STAGE 3

Next, paint the striped top using French Ultramarine with a touch of Crimson Alizarin. Paint the girl's hair with Yellow Ochre, then mix French Ultramarine and Crimson Alizarin for the children's shorts and paint them.

Paint the sea with Coeruleum Blue and French Ultramarine. Then mix Yellow Ochre, Crimson Alizarin and a touch of French Ultramarine and paint the wet sand. Use Cadmium Red for the bucket.

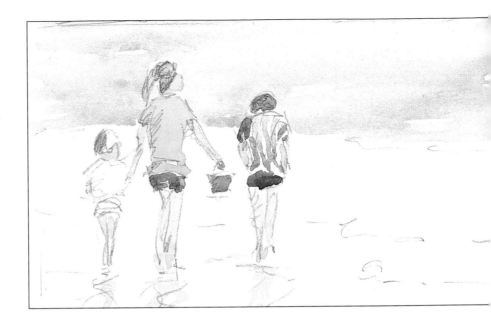

▶ FINISHED STAGE

Cartridge sketchbook
15 × 24 cm (6 × 9½ in)
Paint in the foreground sand using Yellow Ochre and a little Cadmium Red. Also mix in a little French Ultramarine here and there.

Paint the shadows carefully on the figures. The shadows on the rocks and the reflections can be freer. This sketch is more controlled than the previous one but this doesn't mean it's better, just different!

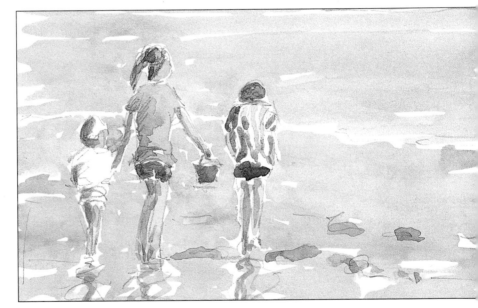

CLOSE-UP DETAILS

◀ *These details are reproduced actual size. Although this painting is more controlled than the one on page 85, the small boy and the reflections are still painted very freely.*

▶ *The child's shoulders are hunched, suggesting that he is looking down and perhaps carrying a bucket with both hands.*

◆ *Beach Scenes* ◆
WORKING FROM A PHOTOGRAPH

This happy seaside scene would inspire any artist! I decided that these three children running into the sea would make a lovely painting. It is important to look carefully at the photograph on the right and see the way the surf crashes onto the beach, leaving swirling patterns around the children. You should also study the patterns surf makes on the beach when a wave flattens out but don't follow these exactly. Simply capture an impression of the scene.

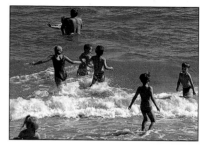

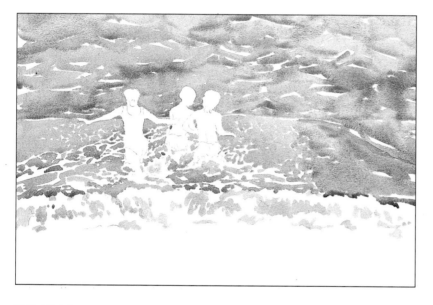

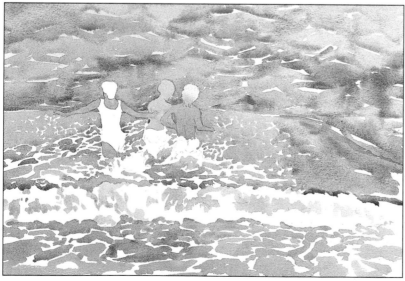

◀ **STAGE 1**

Mix four individual puddles of Coeruleum Blue, Hooker's Green No. 1, Yellow Ochre and French Ultramarine. Paint the sea down to the children's shoulders using these different mixes. Work your brush horizontally in the way the waves go, with plenty of freedom. Carry on working down into the big wave to the left of the children, with a new mix of Hooker's Green No. 1 and Yellow Ochre, leaving white paper for the foam.

 Add more Yellow Ochre and a touch of Crimson Alizarin when painting the immediate right of the children and more French Ultramarine for the extreme right. With the various sea colour mixes, continue painting the sea, leaving plenty of white paper for the foam.

◀ **STAGE 2**

Use your No. 6 brush and a mix of Yellow Ochre and Cadmium Red to paint the girl's flesh. The middle boy's skin should be Crimson Alizarin, Cadmium Yellow mixed with plenty of

88

water, and the third child is a combination of these mixes. Paint the wet sand with your No. 10 brush using this flesh colour mix plus a little French Ultramarine here and there. Don't try to copy every wave and foam pattern. It just isn't possible and you will lose the lovely free watercolour look.

▶ STAGE 3

Use your No. 6 brush to paint the girl's hair and use a mix of Yellow Ochre and a touch of Cadmium Yellow. Do the middle boy's hair in Crimson Alizarin, French Ultramarine and a touch of Yellow Ochre, and the third child's hair with Yellow Ochre, Crimson Alizarin and a touch of French Ultramarine.

Use a pale mix of French Ultramarine, Crimson Alizarin and a touch of Yellow Ochre for the girl's swimsuit. The middle boy's swimsuit is Hooker's Green No. 1 and Coeruleum Blue with a mix for the pattern of French Ultramarine and Crimson Alizarin. The third child's suit is French Ultramarine, and Cadmium Yellow for the pattern.

Next, paint a very watery wash of French Ultramarine and Crimson Alizarin on the lower beach.

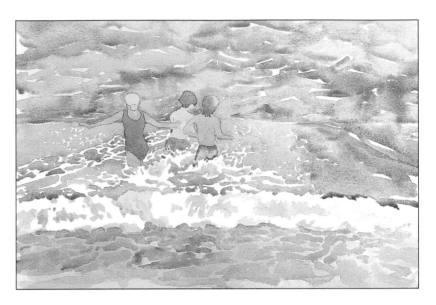

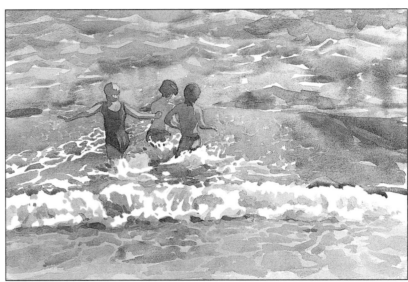

▲ FINISHED STAGE

Bockingford 200 lb
35 × 56 cm (14 × 22 in)
Make a watery mix of French Ultramarine, Crimson Alizarin and a touch of Yellow Ochre and paint shadows on the waves (but not too many) with your No. 10 brush. Add more water and a touch of Crimson Alizarin to paint the big wave in front and around the children, leaving some white foam. Change to your No. 6 brush and use the same shadow colour – but much stronger – to put shadows on the girl's flesh, hair and swimsuit. Paint a weaker shadow on the middle boy and a warmer shadow (add Cadmium Red) on the third boy. Finally, mix French Ultramarine, Crimson Alizarin for the shadows on and around the children and use the same colour to give form to the foam, adding Yellow Ochre in places.

June Crawshaw

◆ Gallery ◆

▲ **What have you found now?**
28 × 38 cm (11 × 15 in)

▼ **The Geese Ball.**
28 × 38 cm (11 × 15 in)

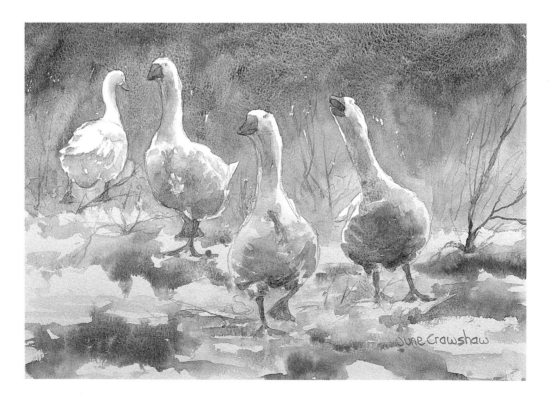

◀ *View of Antequera, Spain.*
25 × 38 cm
(10 × 15 in)

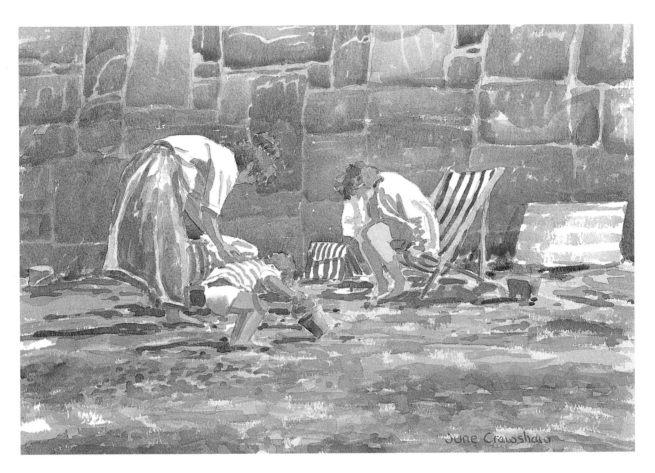

▲ *Getting settled for the day, Dawlish beach.*
28 × 38 cm (11 × 15 in)

▼ *Making mud pies.*
28 × 38 cm (11 × 15 in)

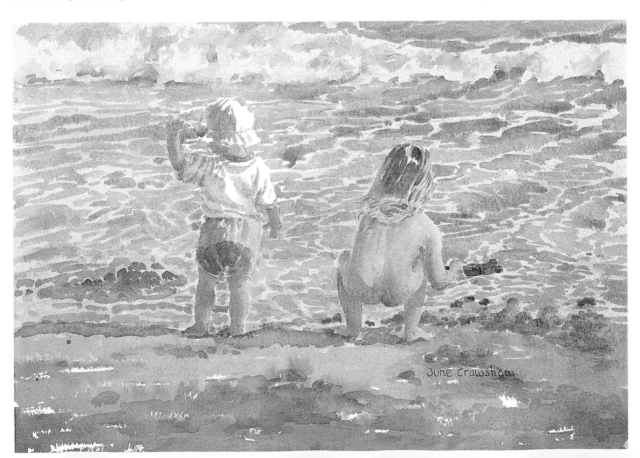

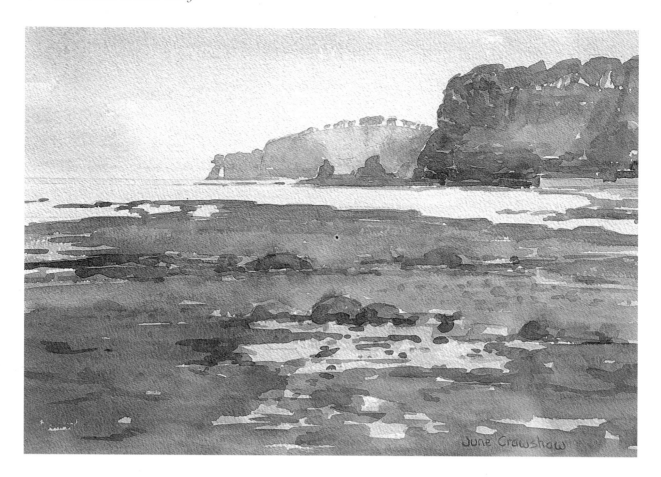

▲ ***Spring tide, Dawlish.***
28 × 38 cm (11 × 15 in)

▼ ***Just swimming along.***
38 × 56 cm (15 × 22 in)

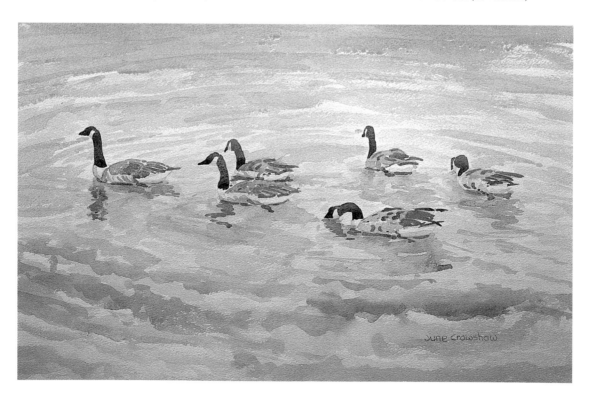

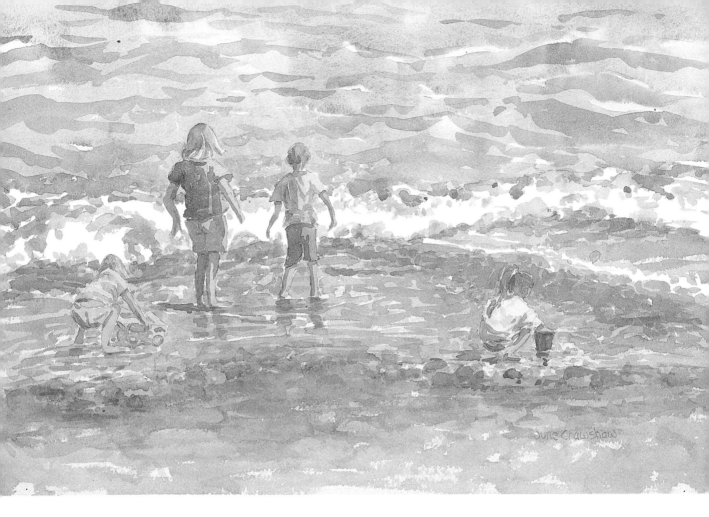

▲ *Summer days.*
38 × 50 cm (15 × 20 in)

▼ *Spring over Dawlish.*
23 × 38 cm (9 × 15 in)

▲ *Flowerpots in my garden.*
25 × 38 cm (10 × 15 in)

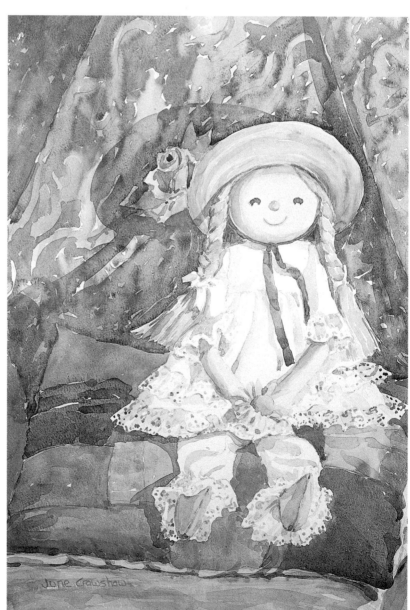

▶ *Mmm...this is soft!*
56 × 38 cm (22 × 15 in)